100 VIEWS OF THE HAMPTONS

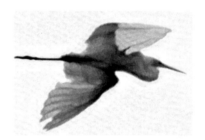

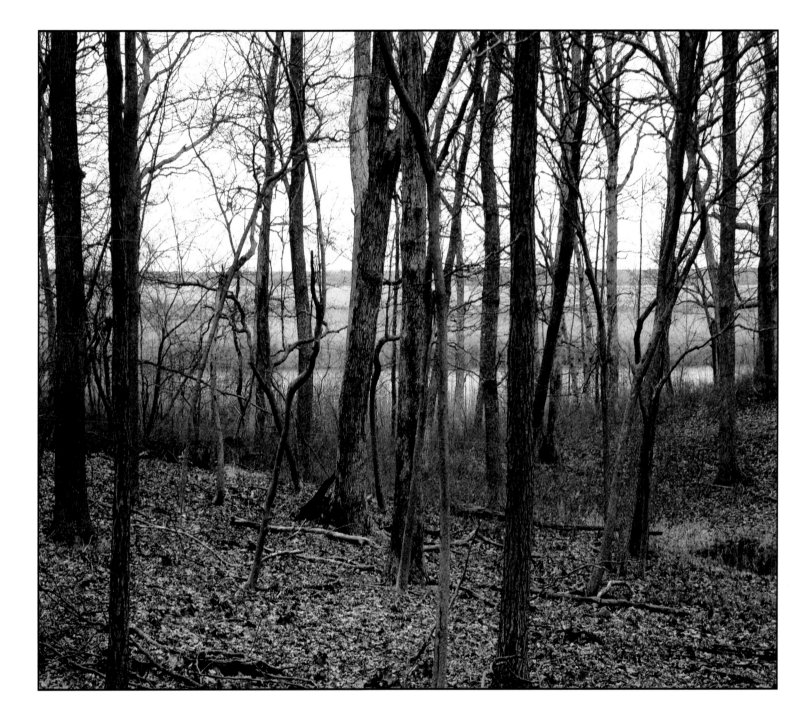

100 VIEWS OF THE HAMPTONS

PHOTOGRAPHS BY KEN ROBBINS

ACCABONAC BOOKS

Published by Accabonac Books
921 Fireplace Road,
East Hampton, New York 11937
Manufactured in the United States
Printed by Penmor Lithographers, Lewiston, Maine

Library of Congress Control Number: 2006900859
ISBN 0-9678516-1-0

First Edition

Designed by Ken Robbins

Sheila Robbins, Anthony Brandt, Pamela Williams, and Philip Spitzer are foremost
among many who helped make this book possible. The author hereby offers
heartfelt thanks to them all.

Frontis: *Woods and Water*, used with permission of The Nature Conservancy
Opposite page: *Beach Access, Mainstone Park*

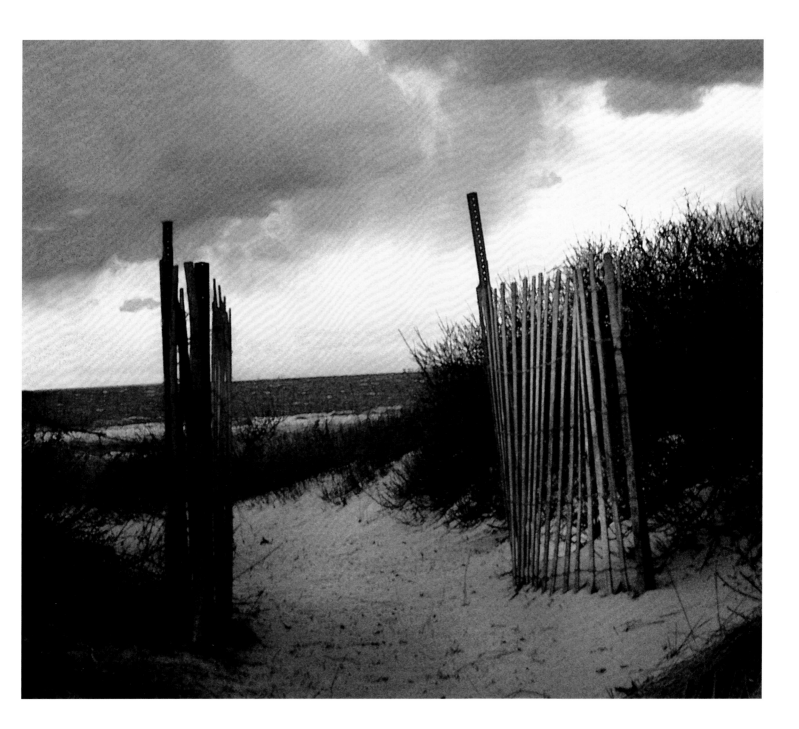

A famous collector once told me that he had trained his eye not just by looking at art, and a great deal of it, but by playing a game with it. He would walk around in a studio or gallery telling himself that out of everything that was on display, paintings, sculptures, prints, photographs or any combination of them, he could have only one thing, one: no more. Amidst the abundance of art available in the world it focused his eye, he said. It taught him to look closely and for a long time at art, to compare and think and, finally, to see.

But when I tried this technique on the book you hold in your hands, I couldn't do it. I could reduce the number to five, perhaps, but never to one, and even then I would wander back through the pages and find something else that was just plain straightforwardly beautiful, or another witty juxtaposition of images, or an unexpected stunning demonstration of compositional skill I had not noticed before. The book overwhelmed me. Ken Robbins' work has impressed me for years, but this is different. This is the kind of work we can only describe as a breakthrough. We are watching a really good photographer, sensitive and thoughtful, with an acute feel for composition, transform himself into a major artist. If you happen to know him, as I do, it is a humbling experience. It's also more than a little exciting.

Look at "Heat Shimmer," for example, in the first section of the book. Beach scenes with umbrellas were a trademark of the American Impressionist William Merritt Chase and Robbins is well aware of this—he frequently quotes from the work of other artists—but see how much farther he takes it here, how he eliminates the horizon, crowds the scene, heats it up, as it were, with people. The picture has a claustrophobic feel; no one is relaxed; it could as well be a city street we're looking at. Yet precisely because it denies our expectations of what a beach scene is supposed to look like, human beings here, distant horizon there, it gains a power no one could have predicted. The picture has taken a familiar, even banal emotional trope and suddenly extended its range. And then, on the facing page, another scene, "Beach Fog," drives the point home. Now it is fog, not people and their umbrellas, that obscures the ocean and eliminates the horizon. Either way we do not see it. The ocean is invisible to us.

Other beach scenes do give us the familiar, but with an emphasis on formal composition; they study the diagonals of beaches, long curves, the shapes of clouds. Or else they open up to the horizon, the "entrance" pictures especially, a break in the dunes where people walk to the beach and catch that first glimpse of the line where ocean meets sky. These are gates-to-the-infinite scenes; they speak to the universal human longing, in the face of the merely physical facts of the world, for transcendent experience. Robbins is fond of these images, but he is careful not to offer anything resembling transcendence. There is an enigmatic character to his pictures that one finds in great art everywhere, a refusal to explain, to denote, to make us feel safe or comfortable in the world. Nothing looks back at us from his photographs. The world is remote, self-contained. Robbins imports moons into his pictures at every opportunity; they come close to being a signature; but they are also metaphors of reflection and distance and just this sort of unapproachability. Human figures in his landscapes only emphasize this loneliness. A man walks alone across a meadow, just entering the shadows. Another walks with his dog around a corner in the evening. Fishermen stand apart from each other along a curve of beach. Faces are always obscure.

So many of these photographs are amazing. So many. In "Copper Dazzle" a piece of light, coming from who knows where, picks up the coppery color of stones under the shining water at the edge of a beach while in the background a finger of land points to an unusual cloud form, or what may be a piece of fog. The composition is daringly strange, unbalanced even, yet it works handsomely. A few pictures have the simple forms—"Late Sail," for example, a sailboat seen in late light disappearing into a dark background—and stark power of the paintings of the American primitive Albert Pinkham Ryder. Robbins is nothing if not steeped in art history and he knows what he's doing, so we can be sure that pictures like this are self-aware, that he is not only paying homage to various artists but joining them.

Only an artist sure of himself can get away with this. He does. He does it wittily. One can only smile at "Jackson Pollock's Back Yard," a ravishingly beautiful landscape in the pure American Luminist style of the mid-nineteenth century. It is, on one level, no joke. Pollock began painting American landscapes himself in the style of his teacher Thomas Hart Benton. But we cannot help but juxtapose in our minds this picture with the drip paintings we know Pollock for. And when we do, as I say, we cannot help but smile.

Robbins achieves many of his effects by using Photoshop, the computer program that lets you manipulate images at will, and he has become much bolder with it in the past two or three years. It allows him not only to achieve painterly effects on his surfaces but to combine images and to move them around within the frame. What he calls his Fantasias are one result, pictures that evoke the surreal like "The Crossing," where three men in a small boat cross a tiny inlet hardly wider than the boat itself is long, while overhead a pretty little cloud cradles an oversize full moon and a couple of birds pass by. Pictures like these stress the enigmatic in Robbins' work. He makes you want to ask questions to which you know there are no answers. This is what great art does.

The quality of the light he uses has something to do with it. Out here in the Hamptons landscape painting tends to color in the pale pastel ranges, an attempt to catch the subtlety of the famous Hamptons light. Robbins does nothing of the sort. His work is much darker in tone, in every sense of the word; he photographs when the light is leaving the sky or even later, dark birds fly above his landscapes, storm clouds are just moving away, or just arriving. But the result is contradictory. The light seems even more intense, more saturated, for its very evanescence. Everything is stiller. The landscape waits, unapproachable, impenetrable, mysterious. We long for what we cannot possess and cannot know.

Hokusai made himself famous with his 36 Views of Mt. Fuji, Hiroshige with his 100 Views of Edo. Whether Robbins will reach that level of fame is anybody's guess and it is a chancy move to borrow a title from two such masters. Fame is at least half a game of chance. But Robbins has shown us in these photographs that he is a bold man. His work has become a revelation. The word mastery comes constantly to mind. What the future holds for him time will tell, but if it means more work like this we can only rejoice. This is great powerful art.

Anthony Brandt, Sag Harbor, New York

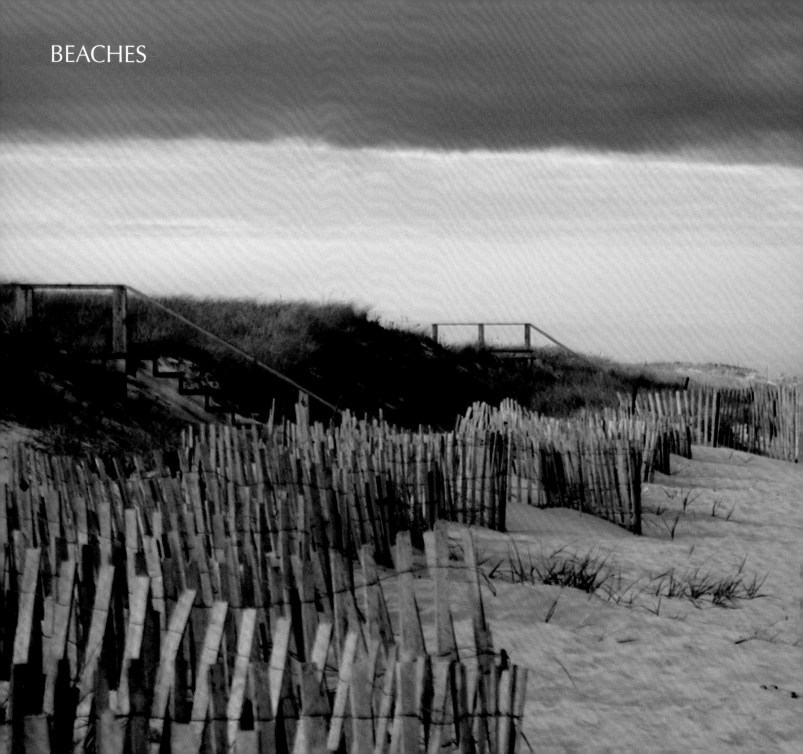

BEACHES

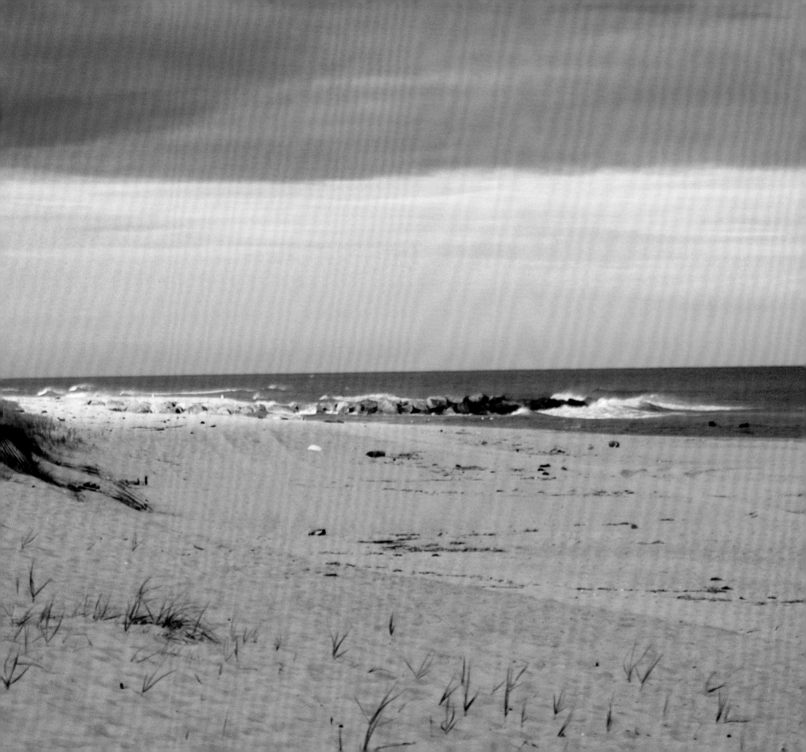

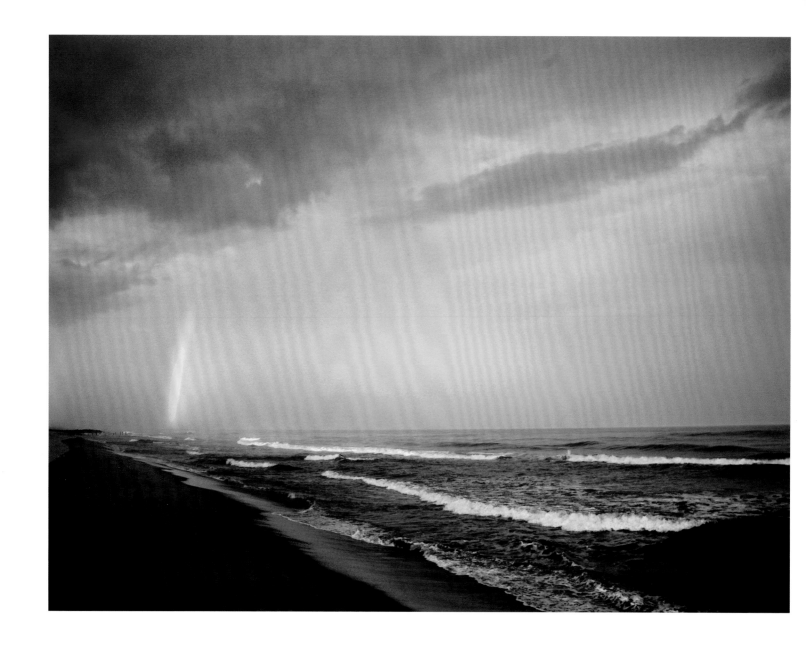

Rainbow and Surf (Main Beach)

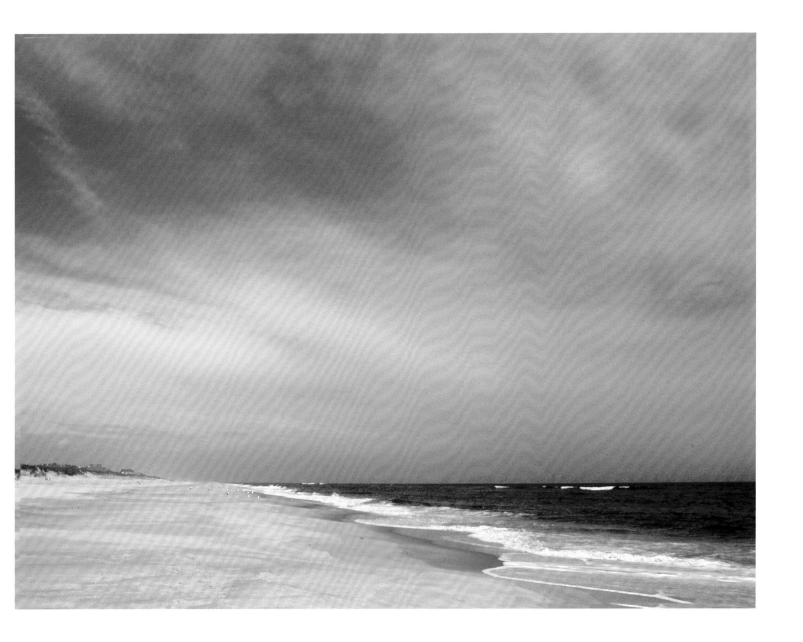

Napeague Surf

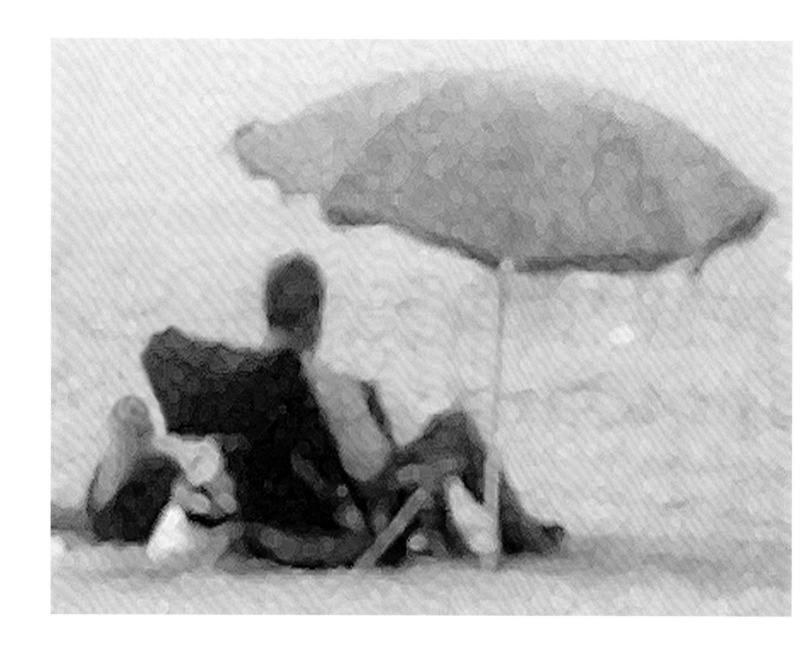

The Blue Umbrella

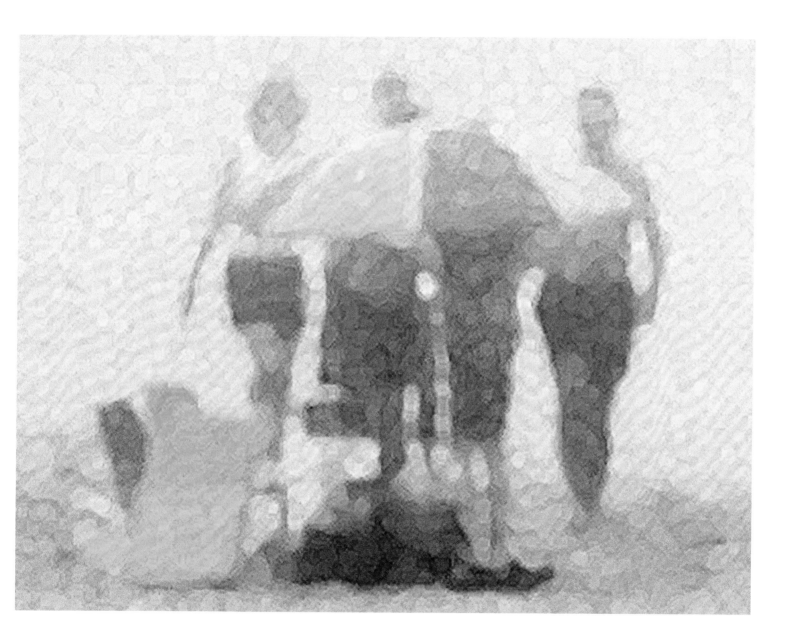

Beach Figures

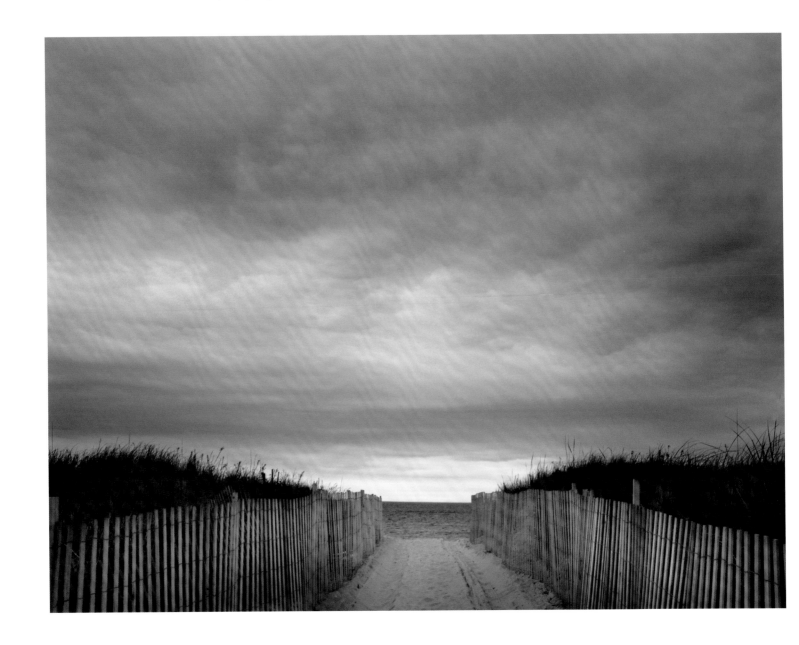

Beach Access with Lowering Sky

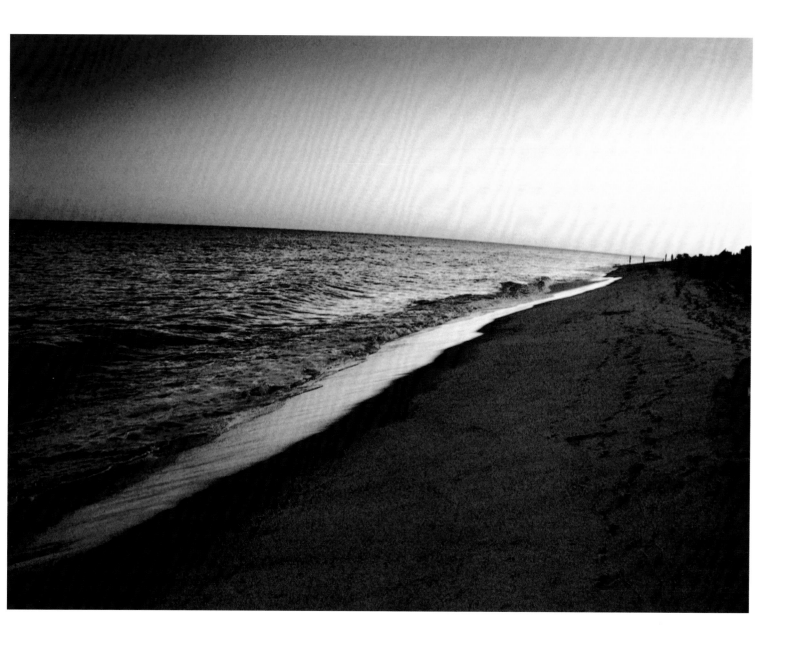

Last Light at the Beach

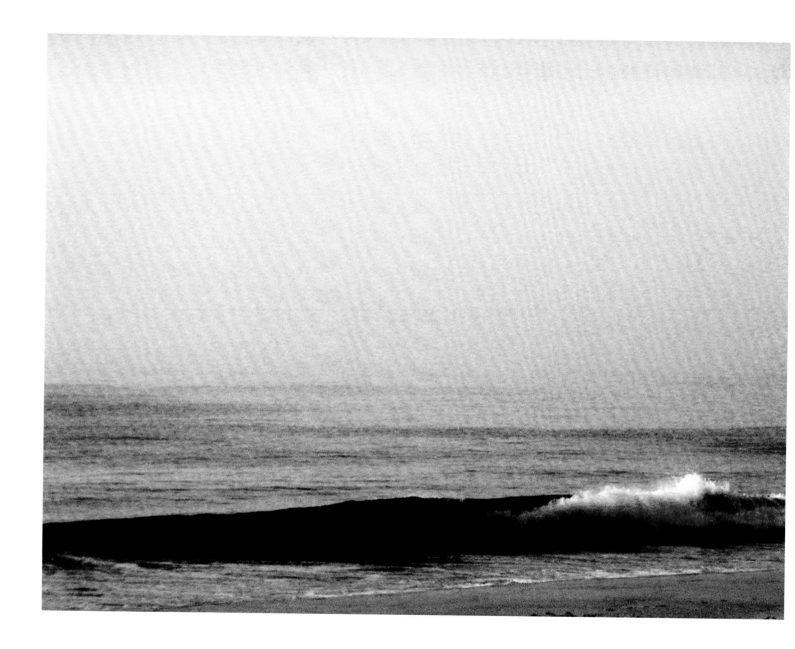

Surf at Dawn

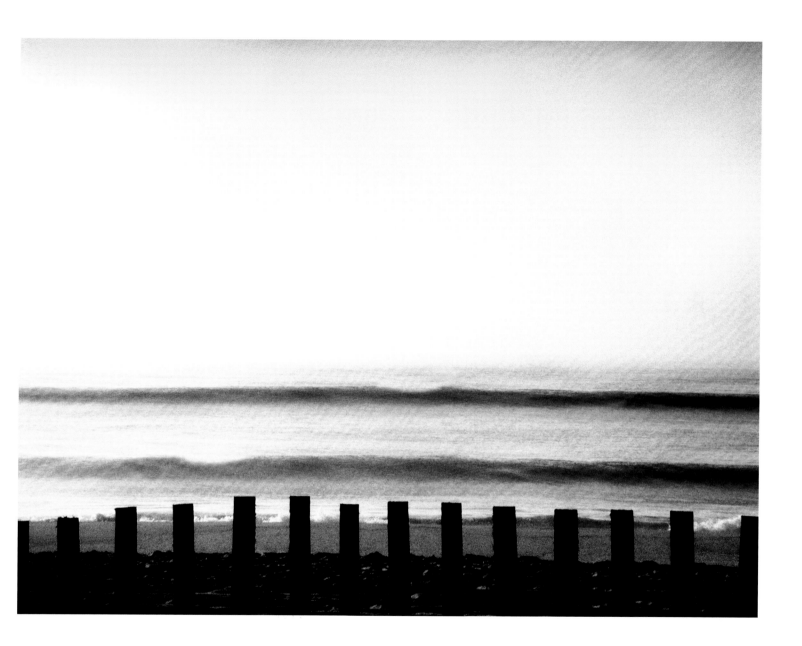

Double Wave

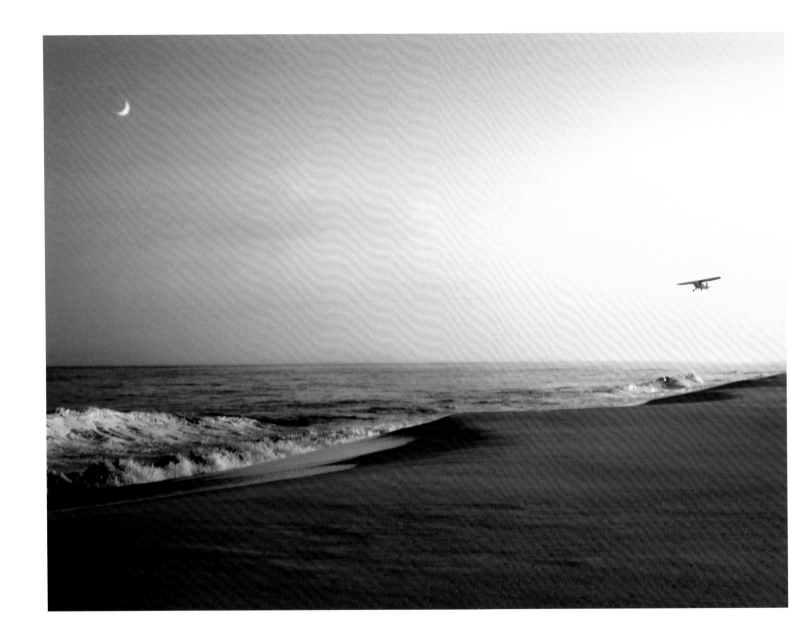

Hugging the Shore

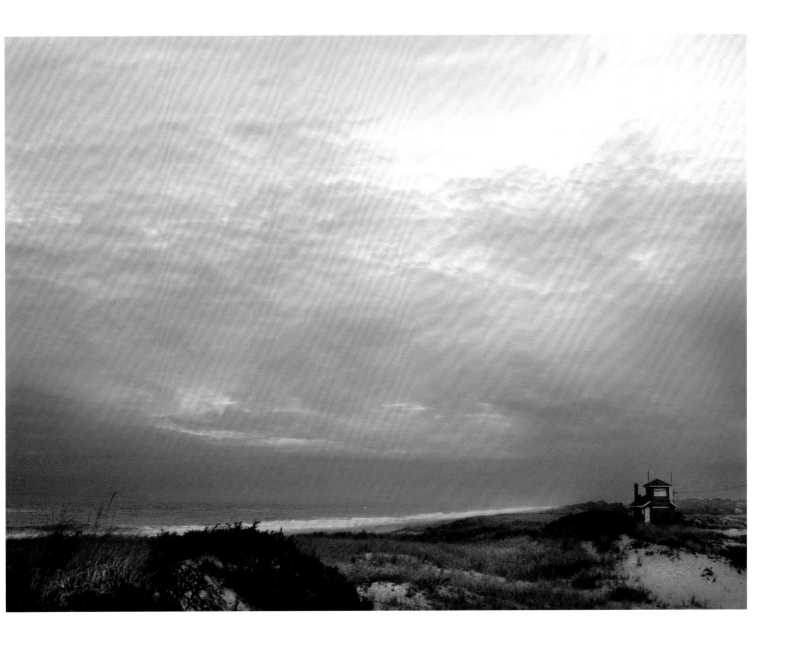

Atlantic Beach, Facing West

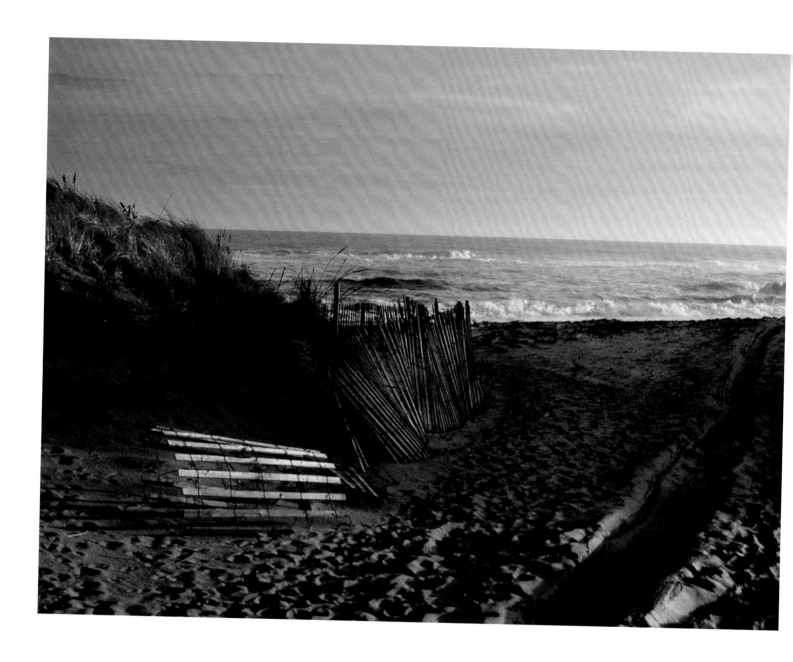

Dune Fence and Surf

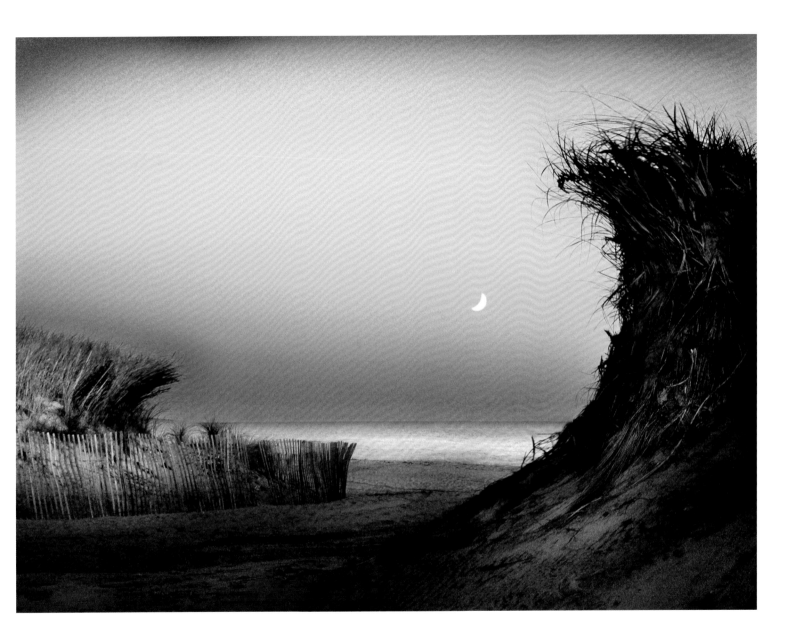

Breaking Dune

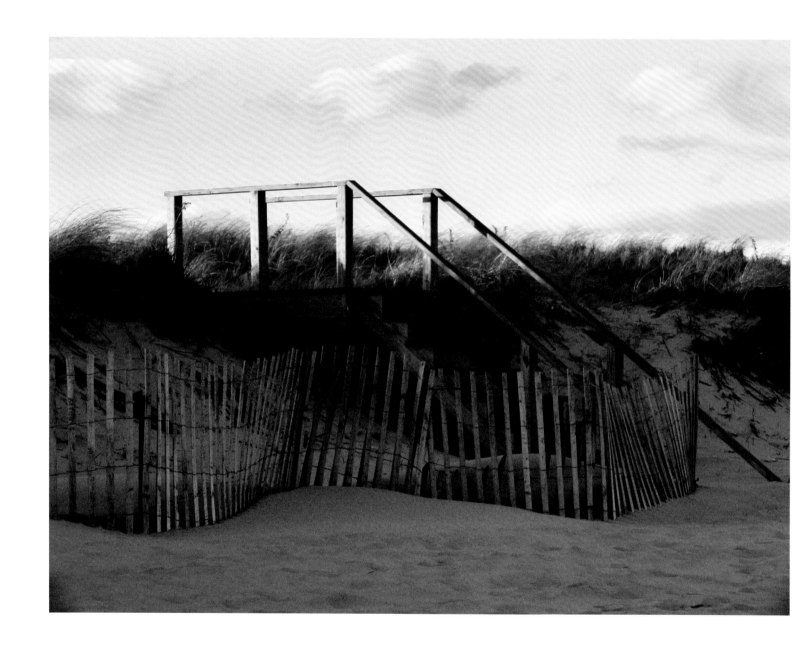

Dune Stairs

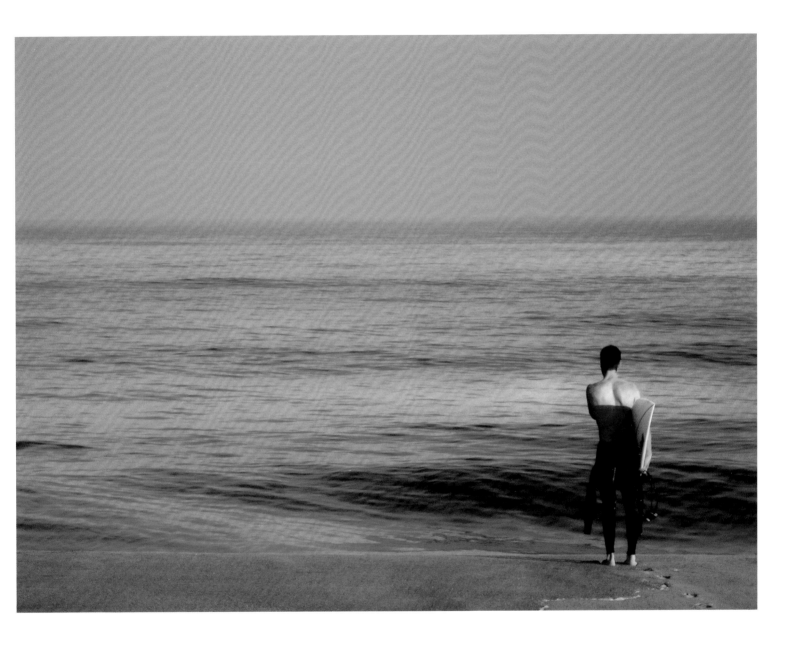

Waiting

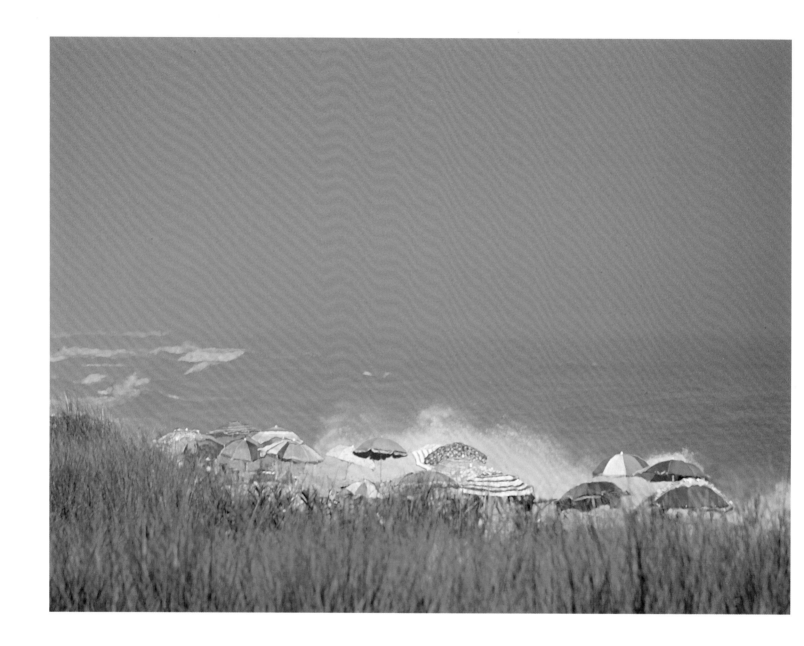

Beach Flowers

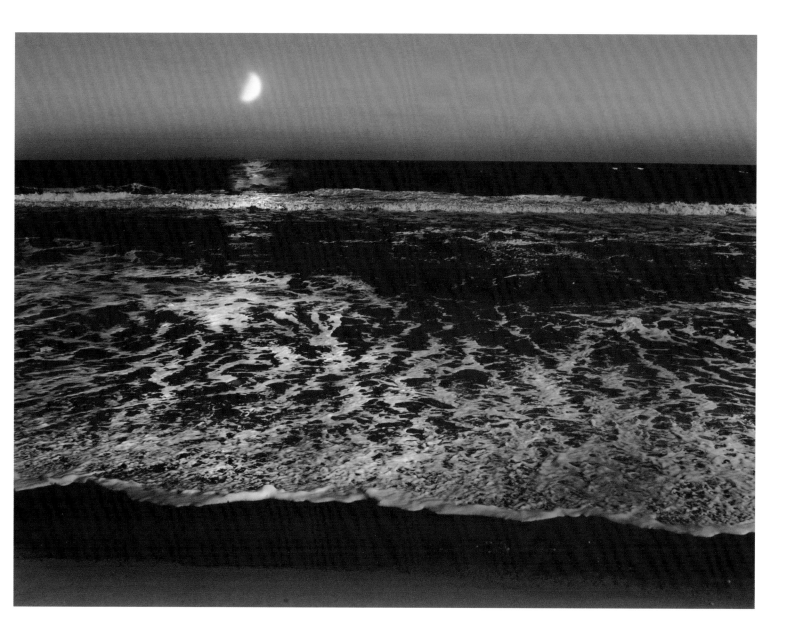

Moonlight and Surf

Heat Shimmer

Beach Fog

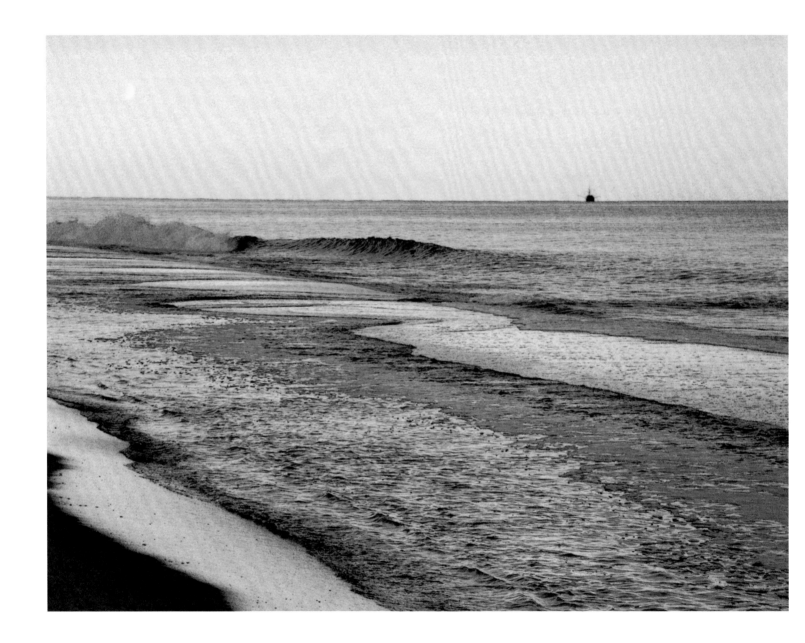

Dragger at Twilight

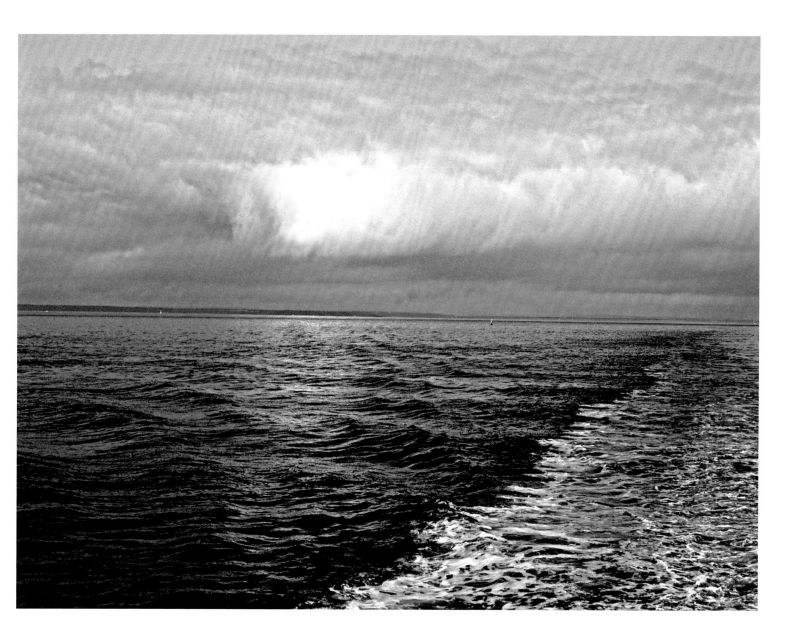

Cloud and Wake

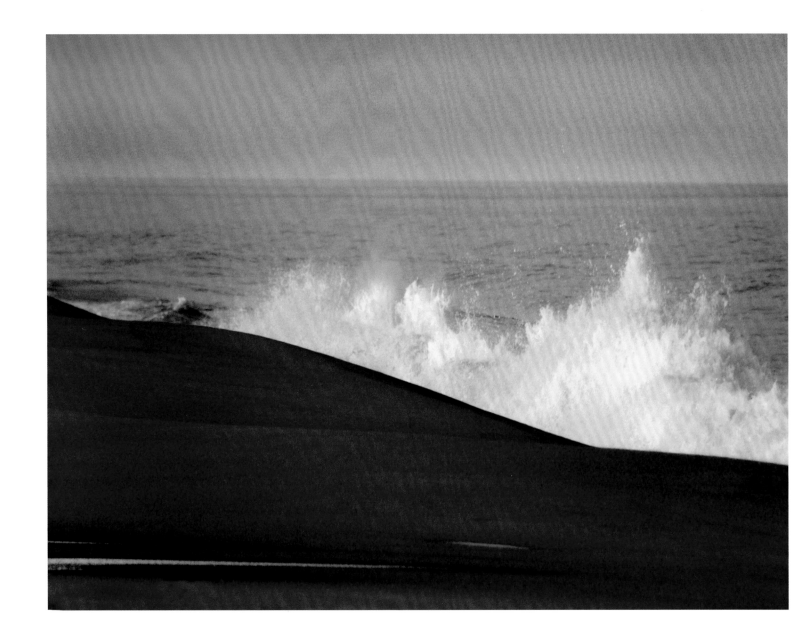

Accent

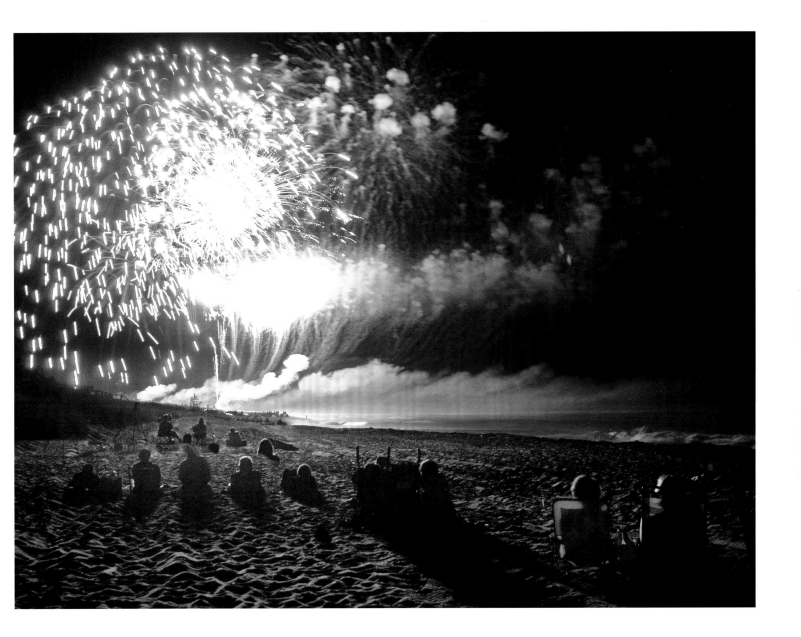

American Spectacle

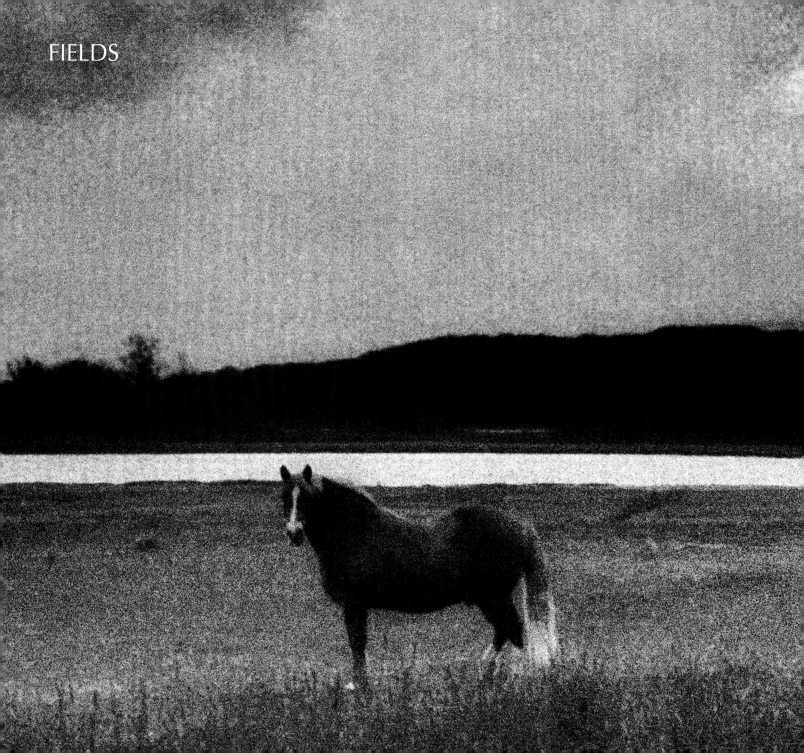
FIELDS

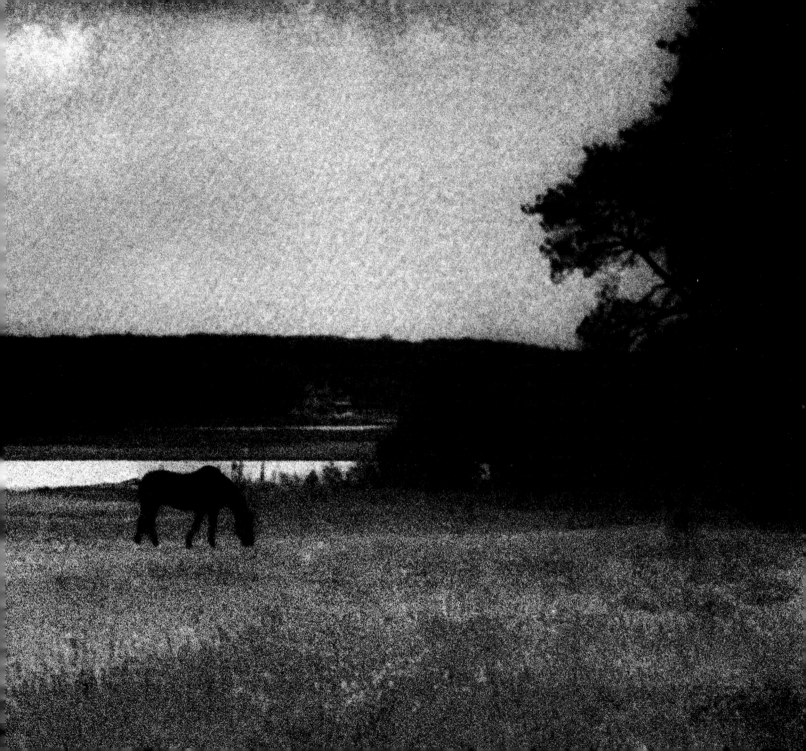

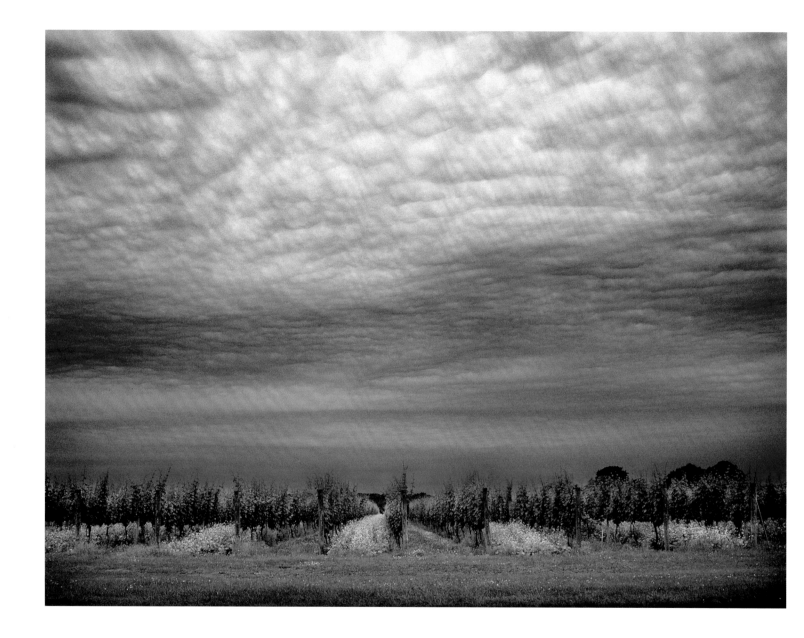

Vinyard

Previous pages:. *Horses, Accabonac*

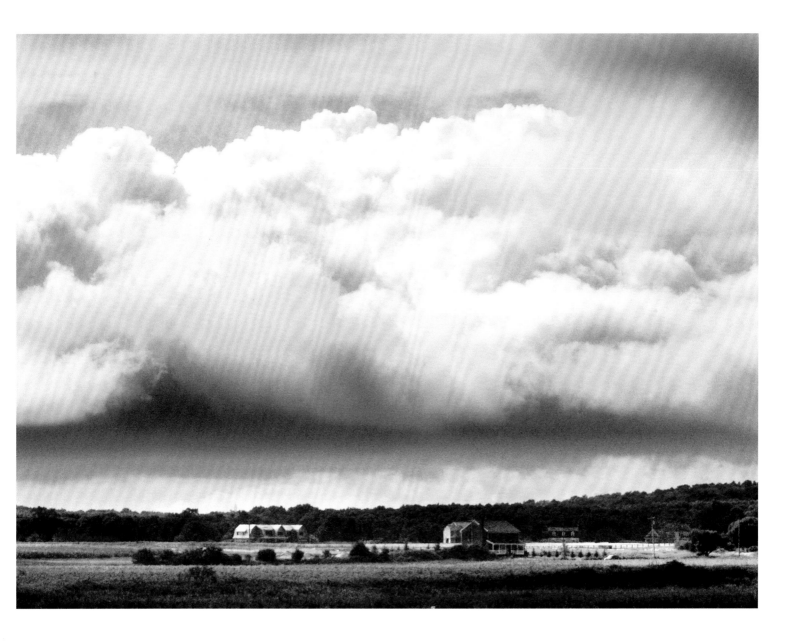

Construction (Sagaponack)

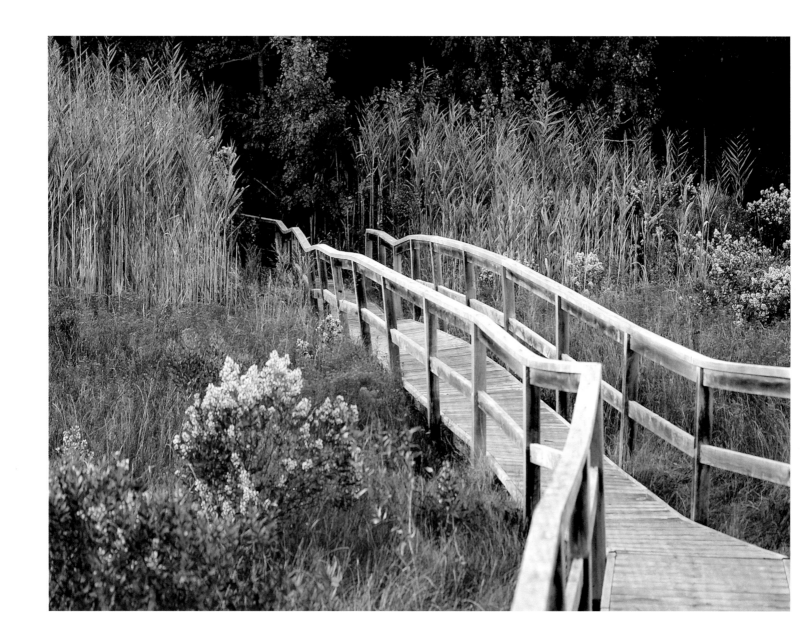

Footbridge, Pussy's Pond

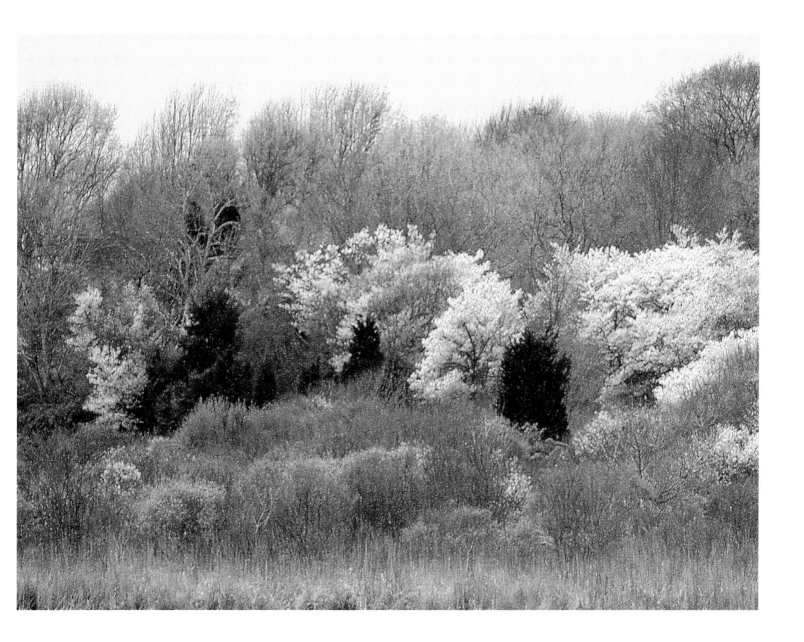

Spring Colors, Hook Pond

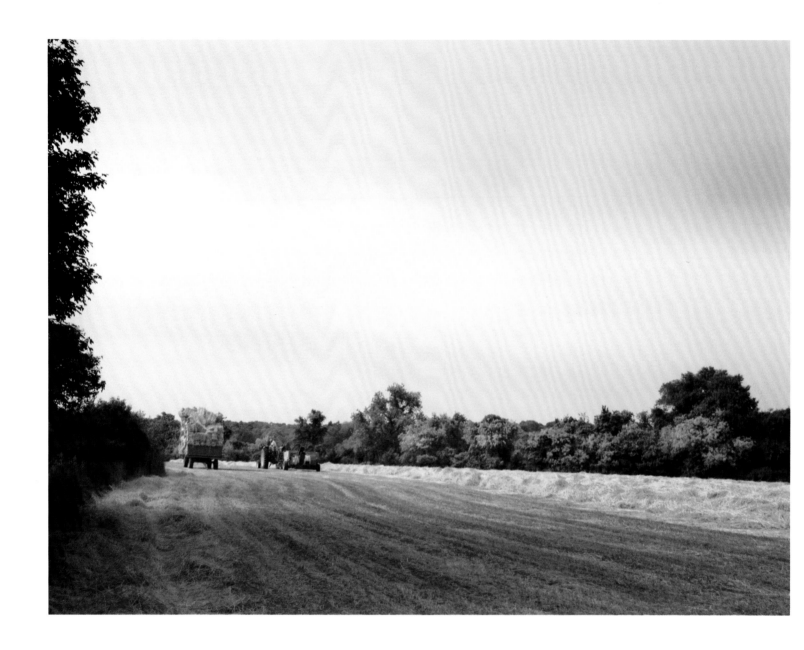

Bailing Hay (Wainscott)

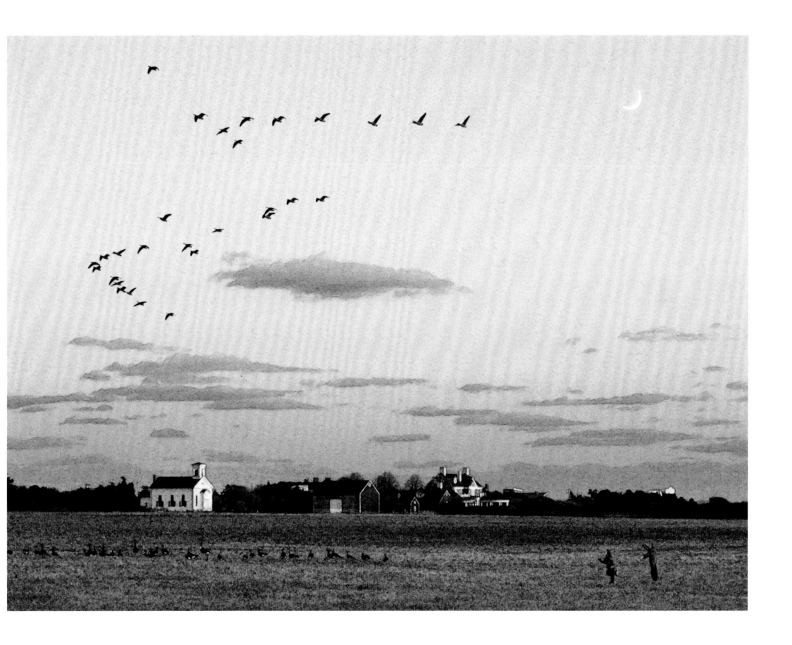

Wild Goose Chase

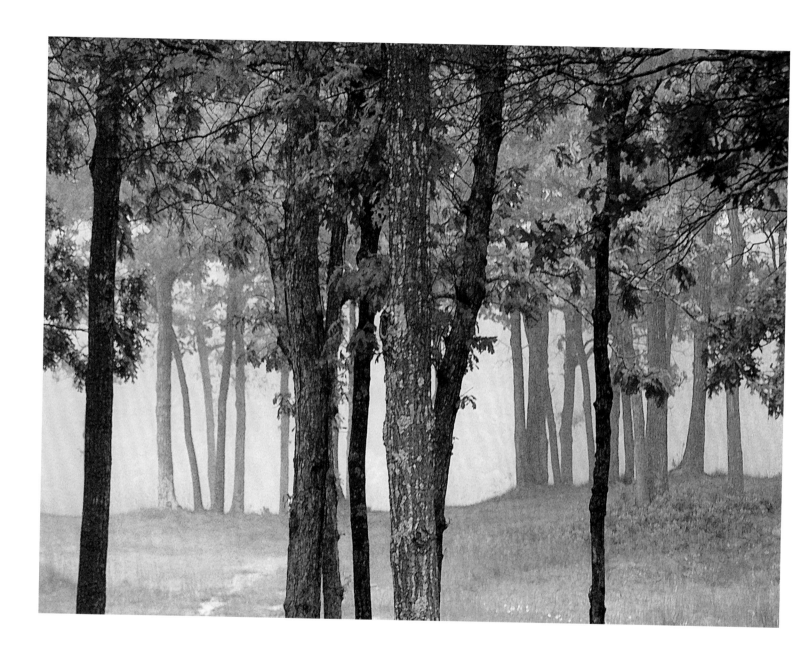

Foggy Woods (Spring)

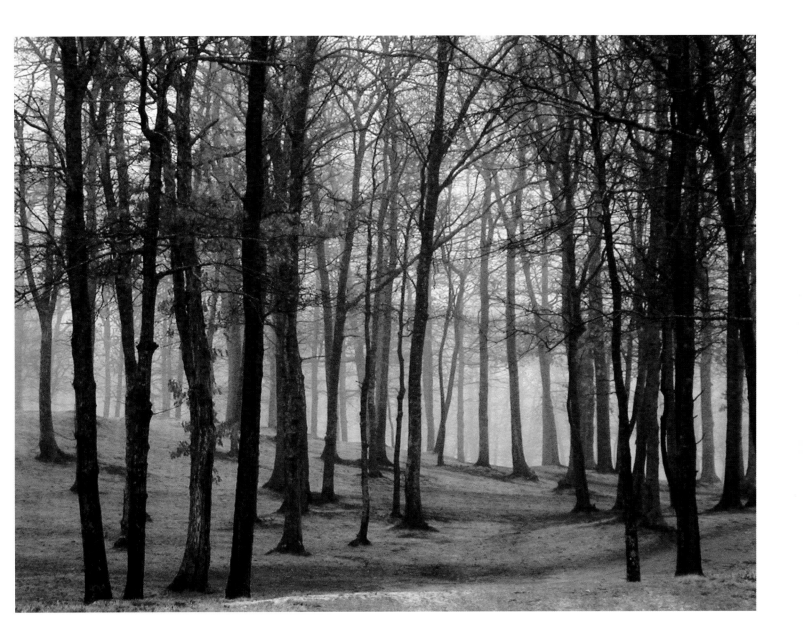

Foggy Woods (Autumn)

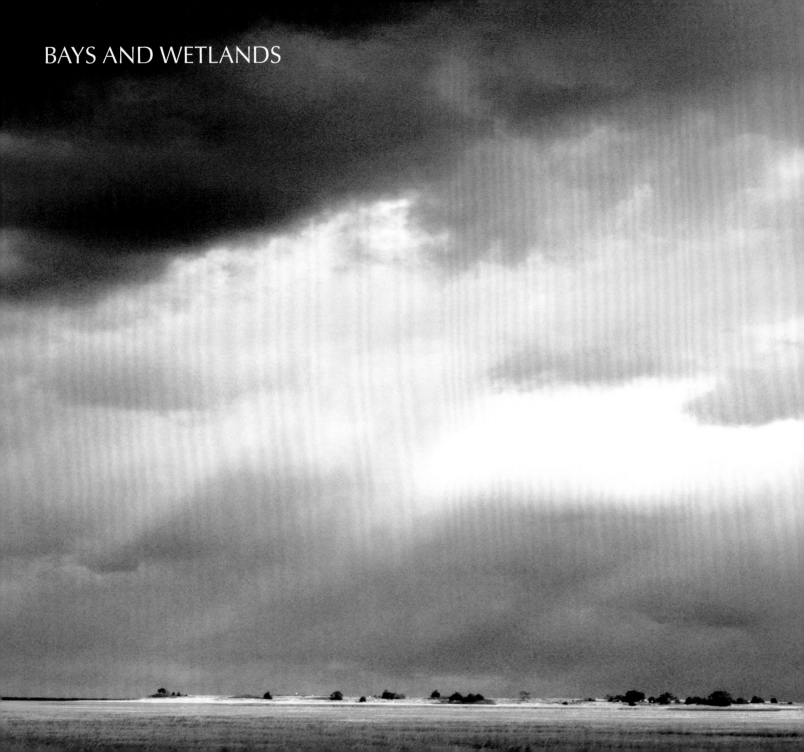

BAYS AND WETLANDS

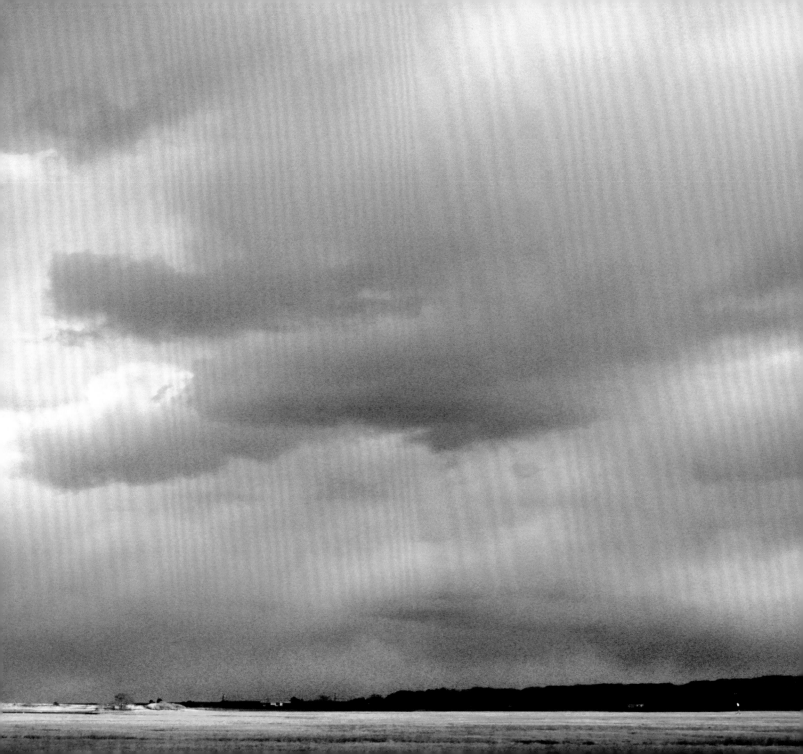

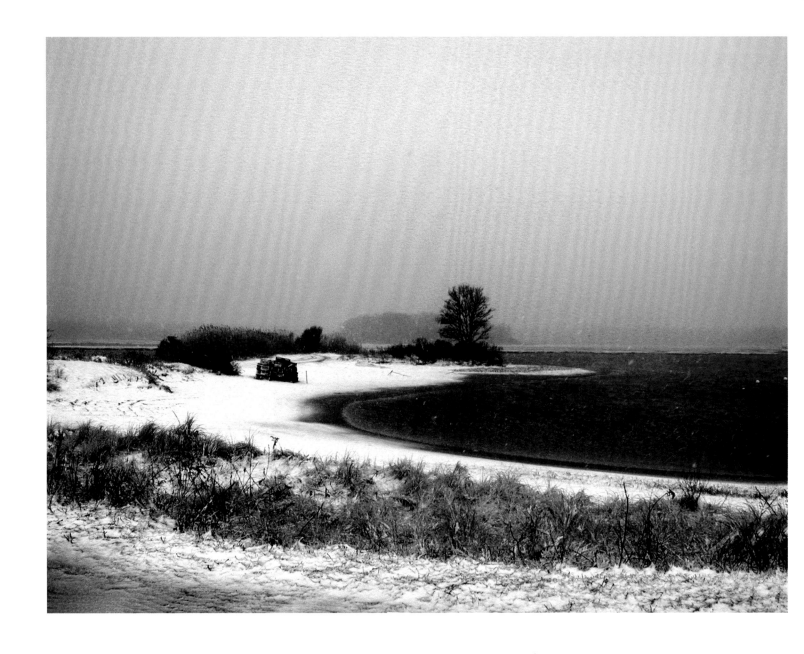

Blizzard (Louse Point)

Previous pages: *Romantic Afternoon*

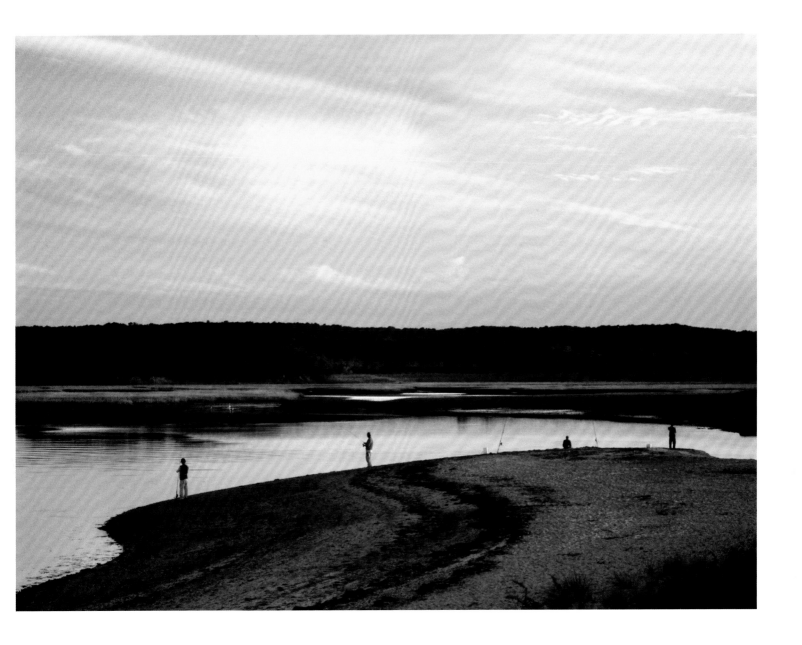

Four Fishermen

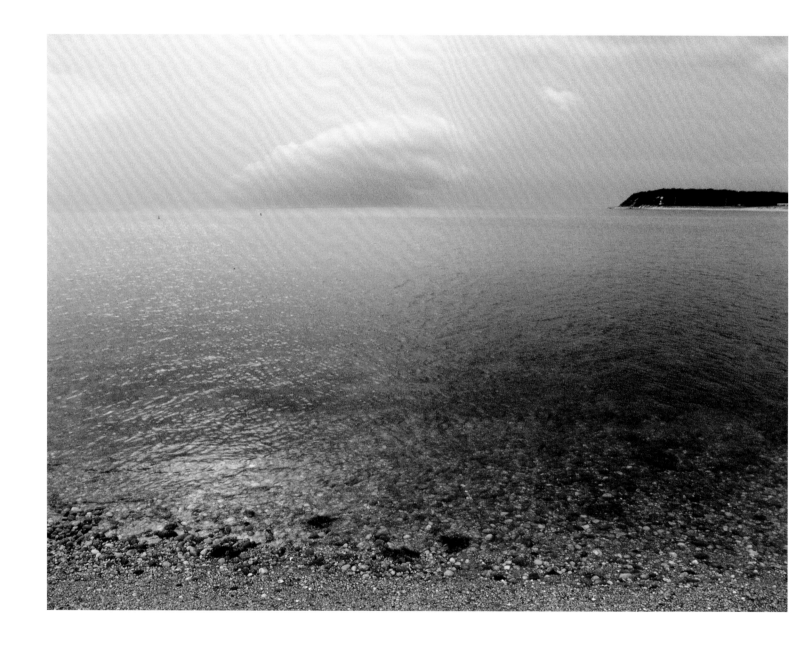

Copper Dazzle

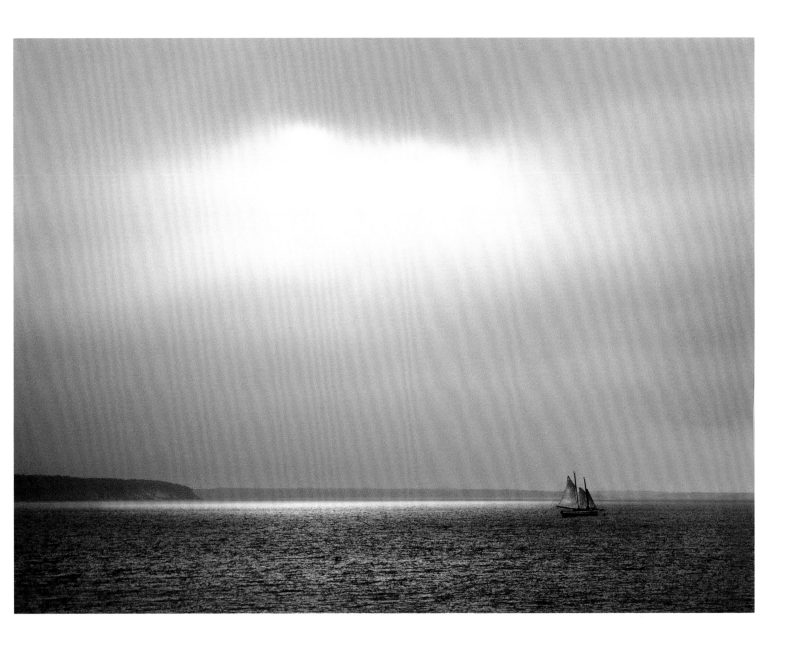

Light on the Bay

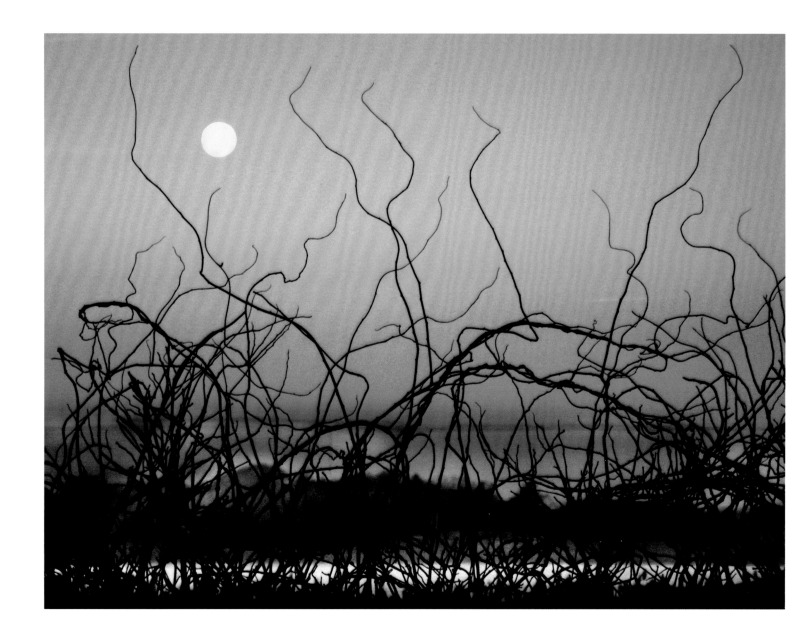

Moon Vines

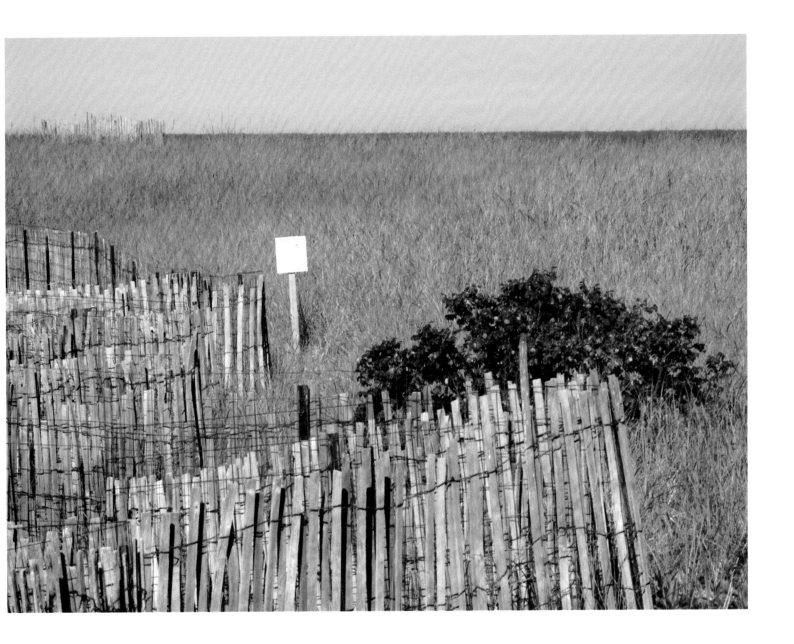

Protected Area

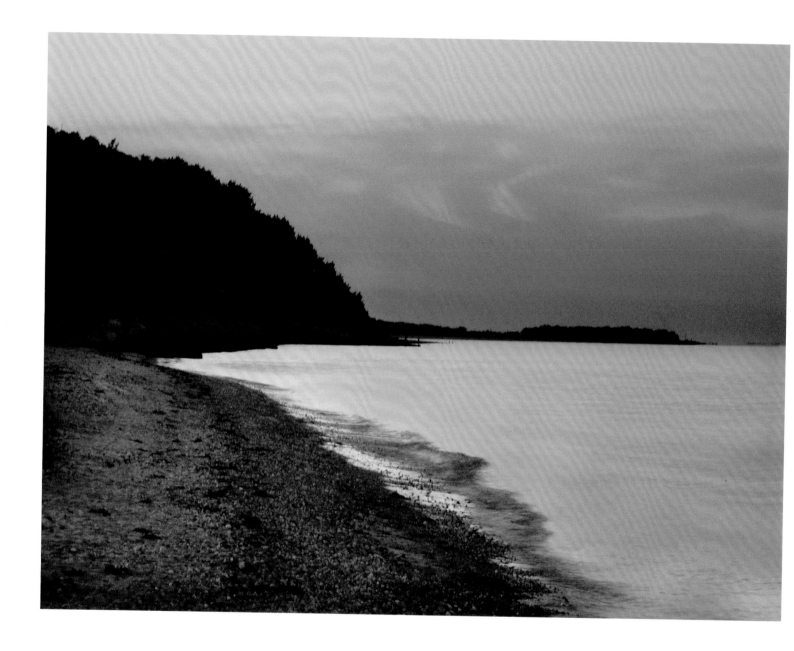

Barnes Hole

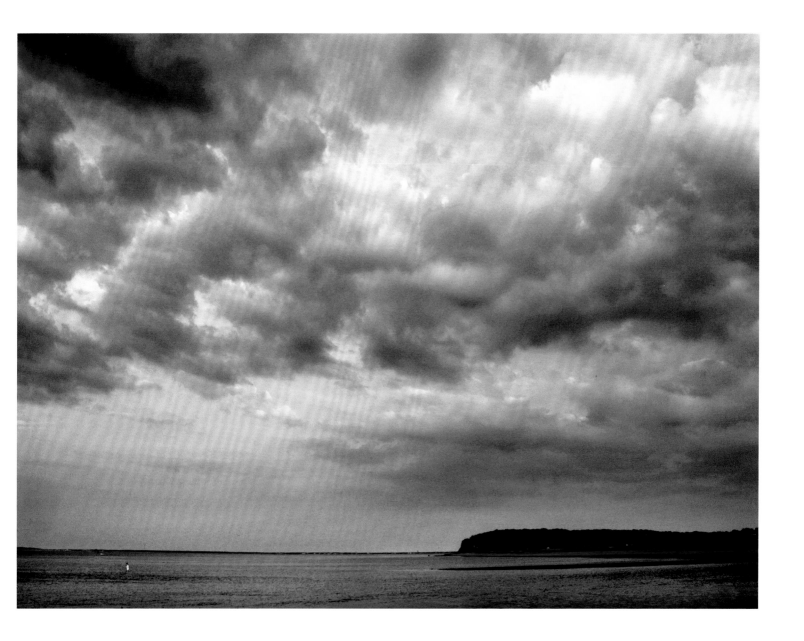

Bay with Rococo Sky

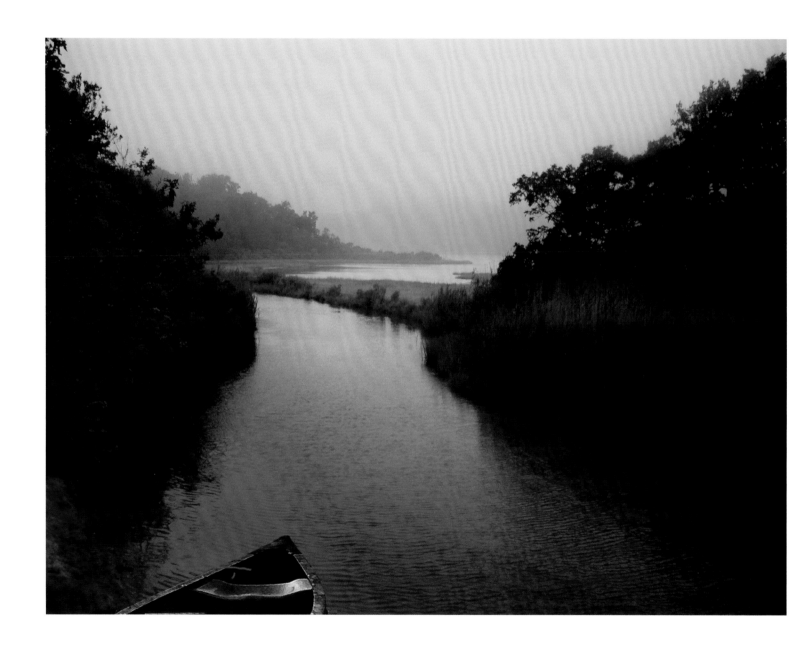

Stygian Beauty, Fresh Pond

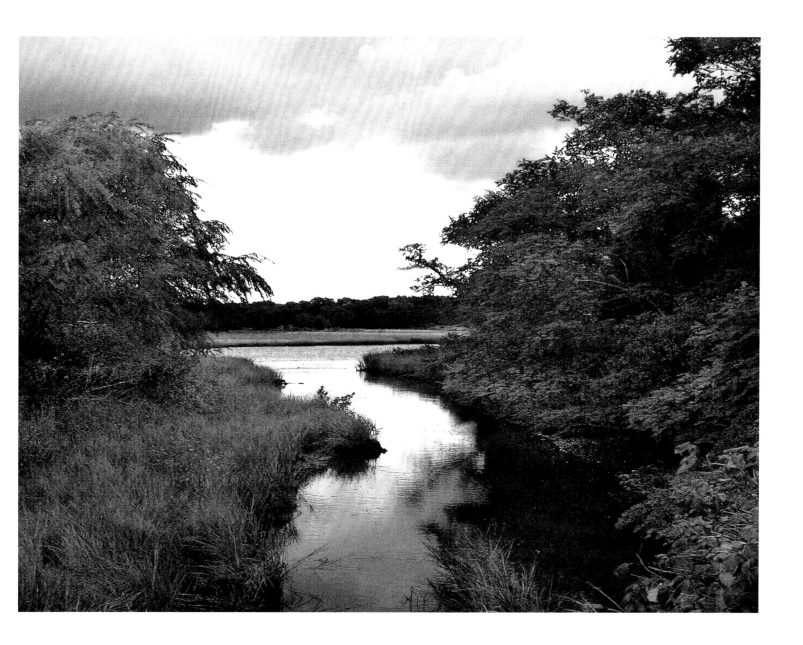

Pussy's Creek

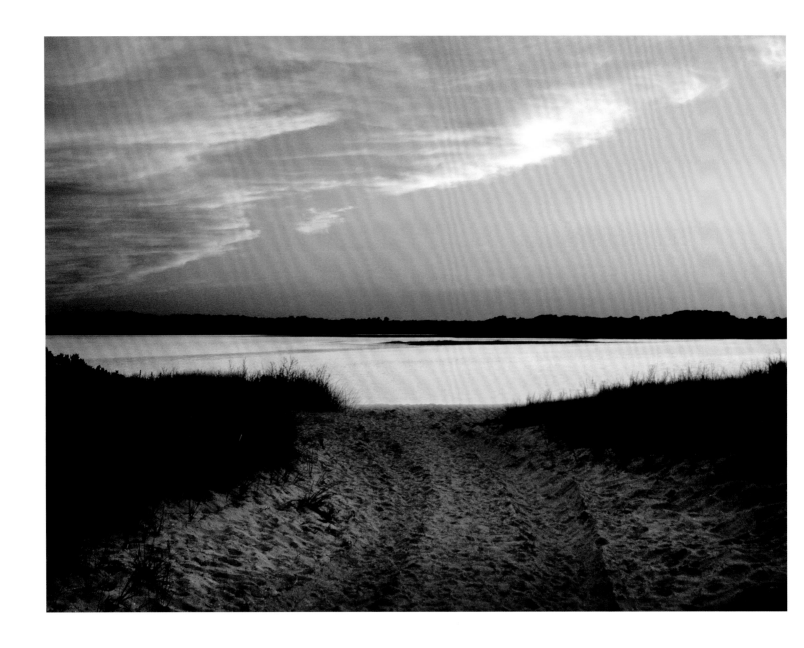

Dusk, Three Mile Harbor

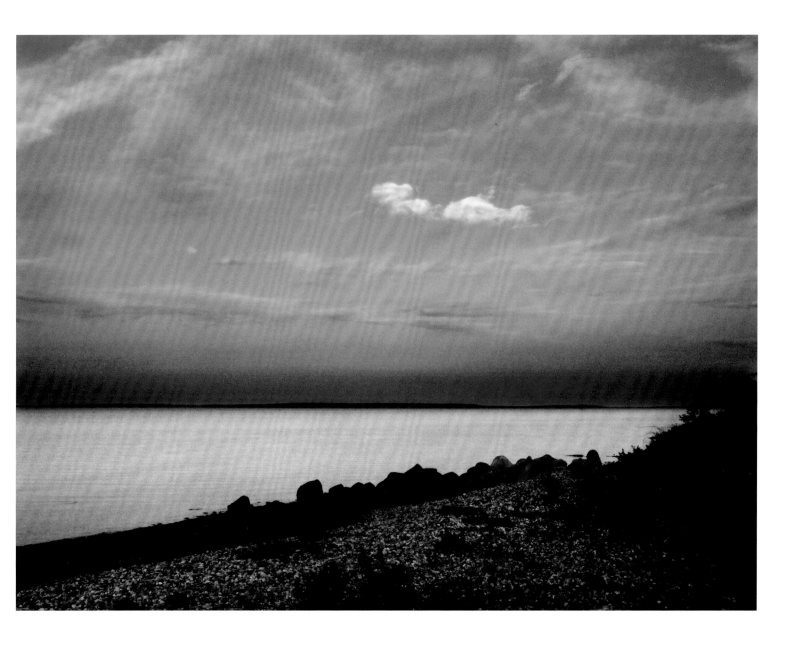

The Illuminati

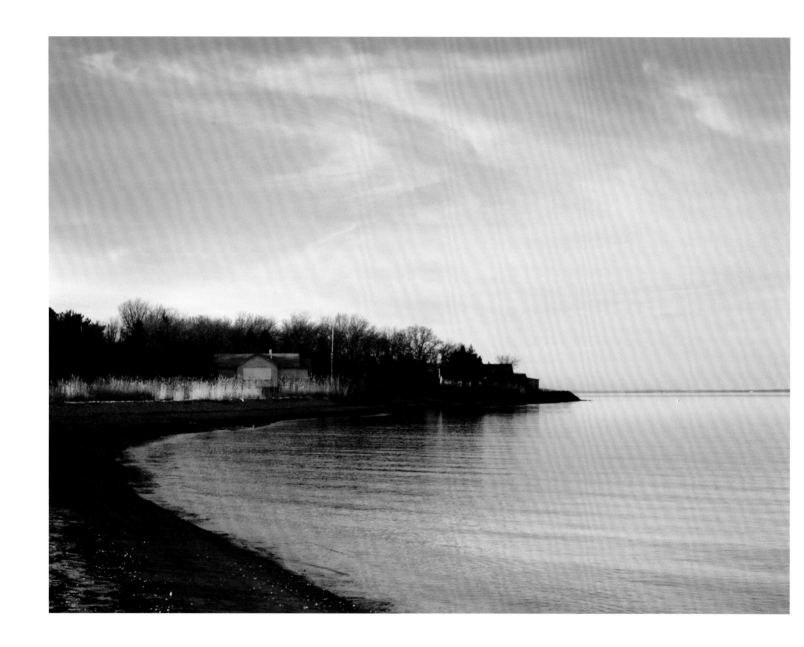

Momentary Gold (Gerard Drive)

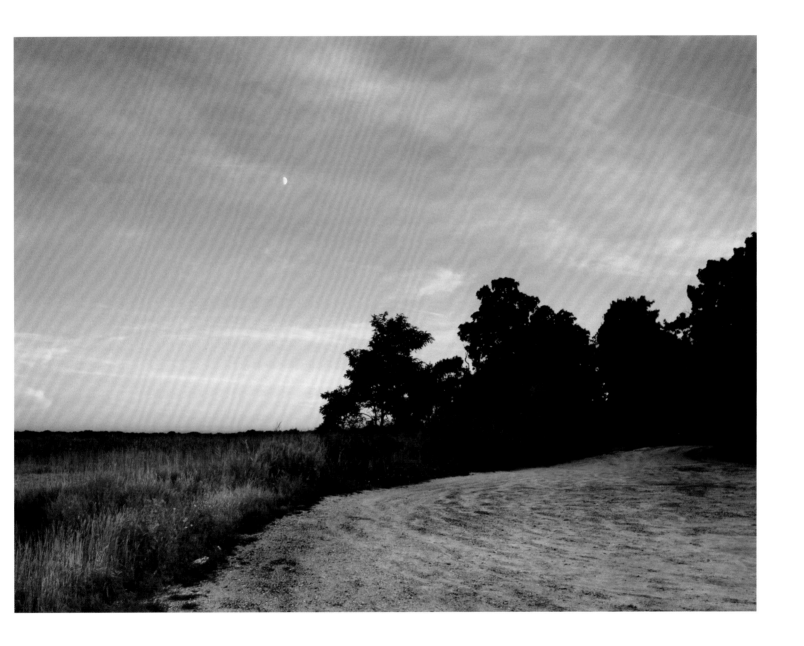

Landing Lane

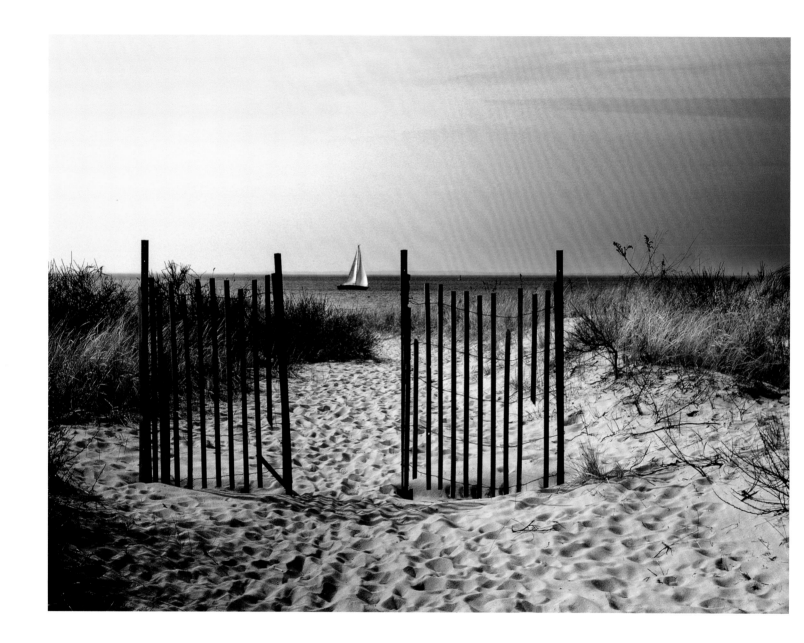

The Gates of Maidstone

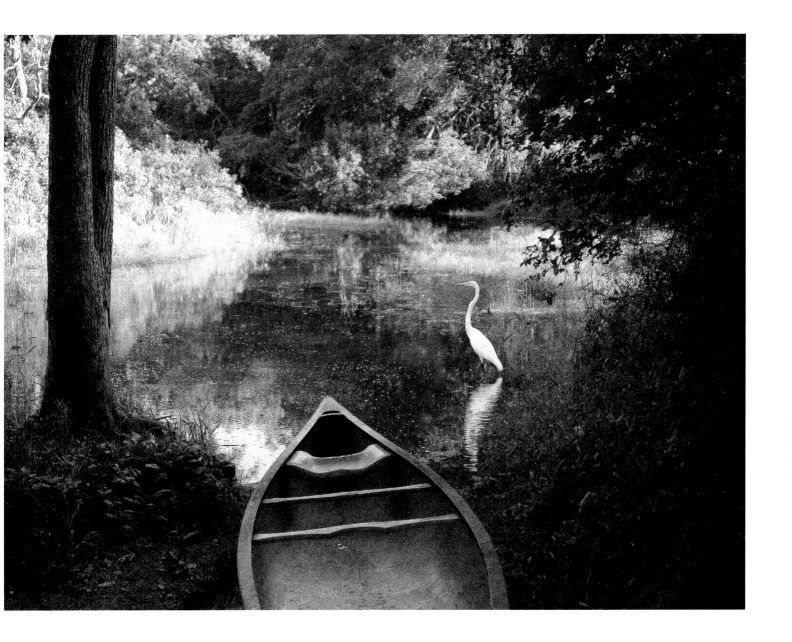

Georgica Creek and Egret

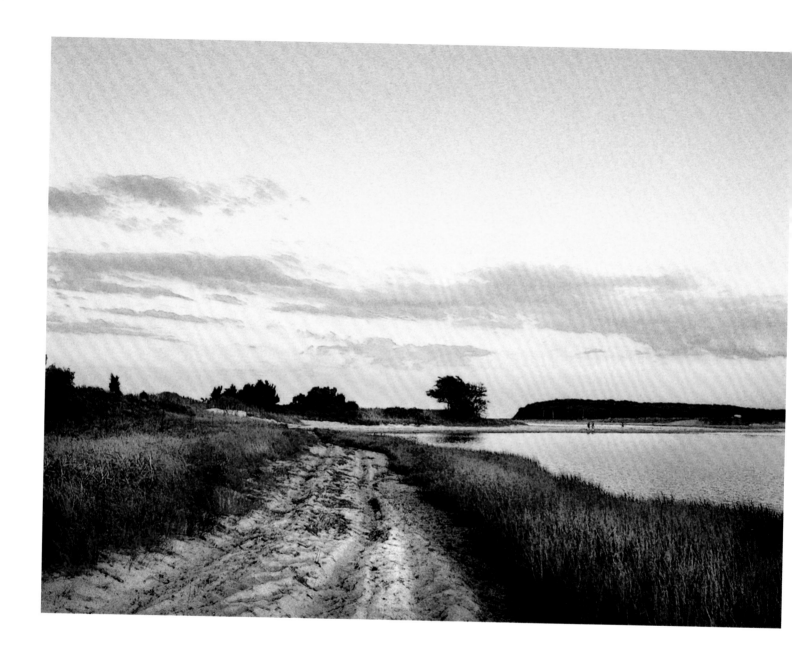

Truck Route

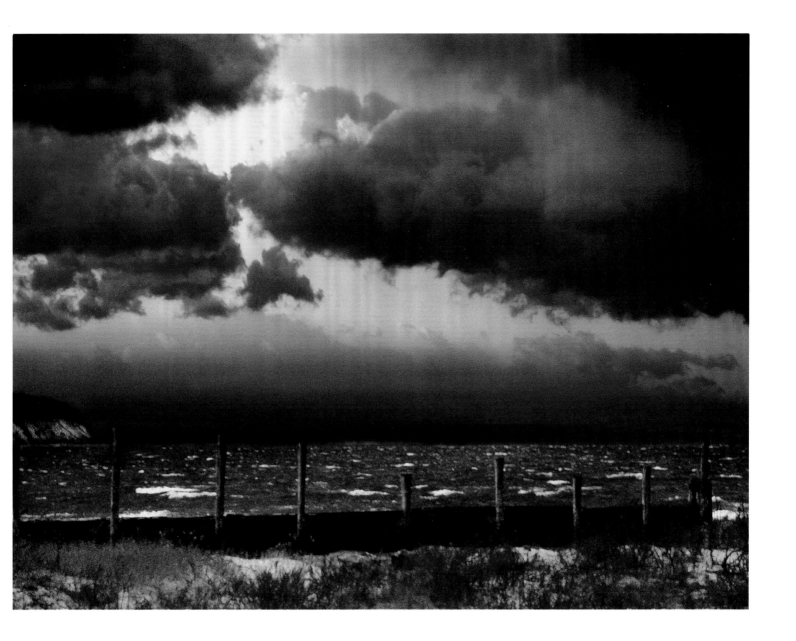

Bulkhead (Three Mile Harbor)

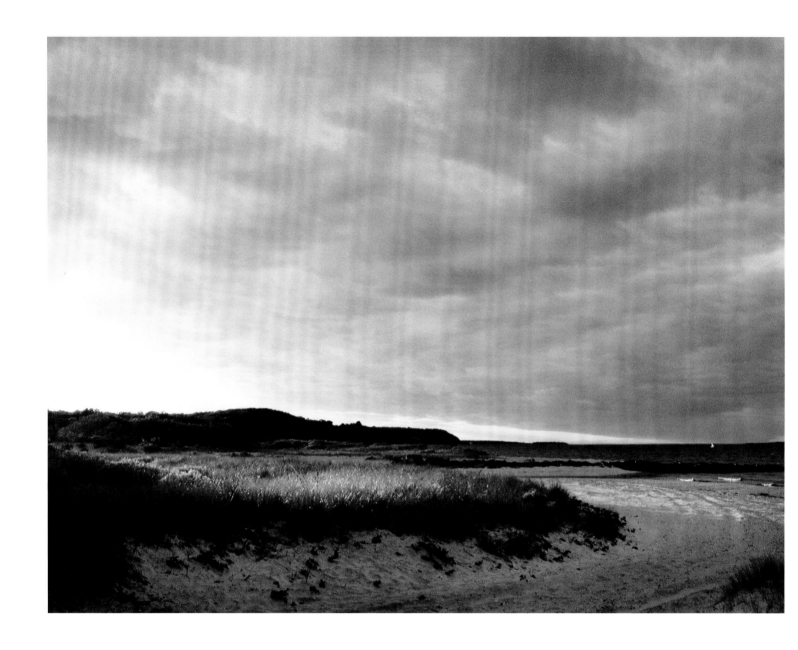

Raking Light, Little Alberts Landing

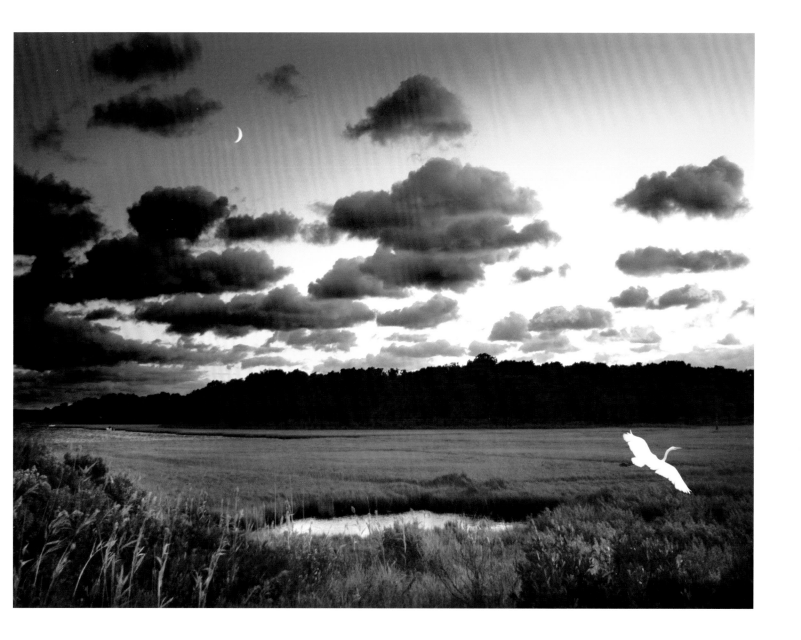

Moonrise, Accabonac

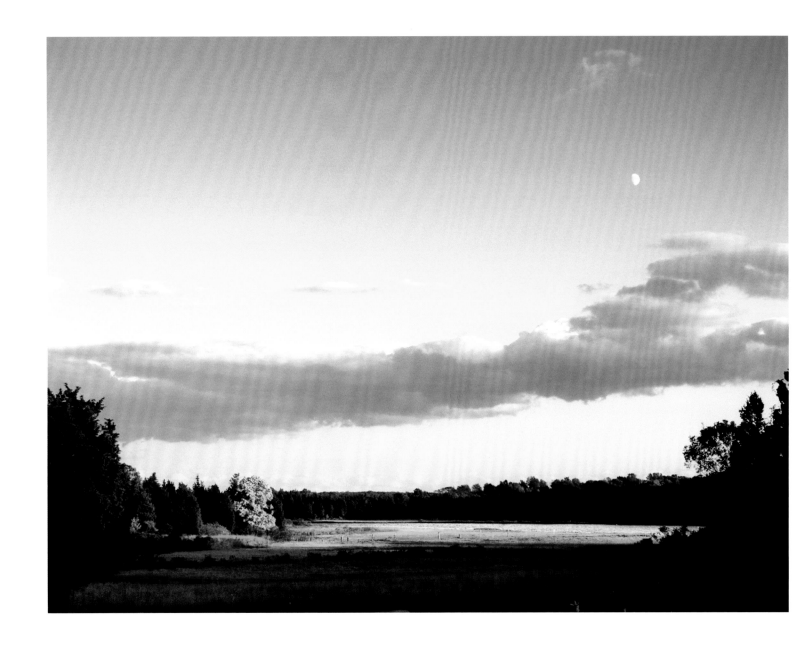

Jackson Pollock's Back Yard

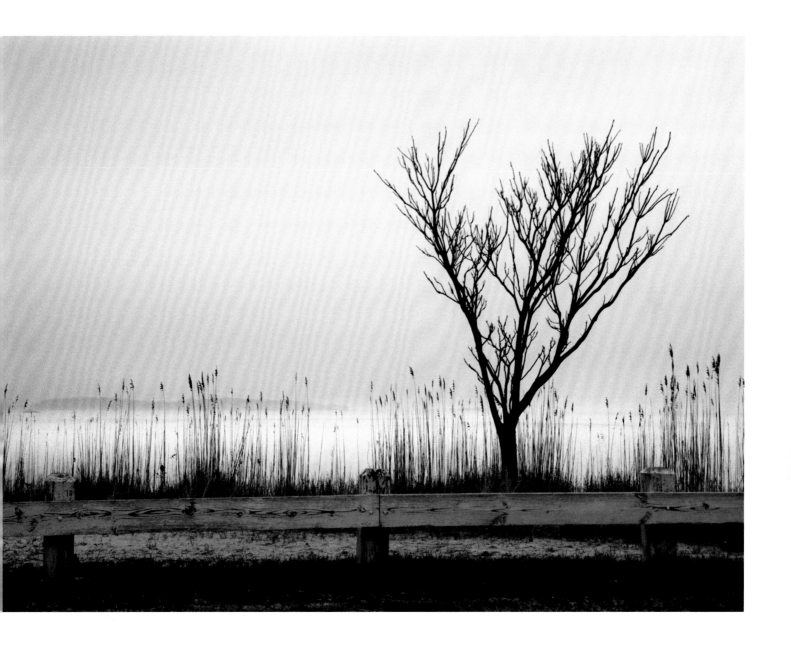

Haven's Beach, Sag Harbor

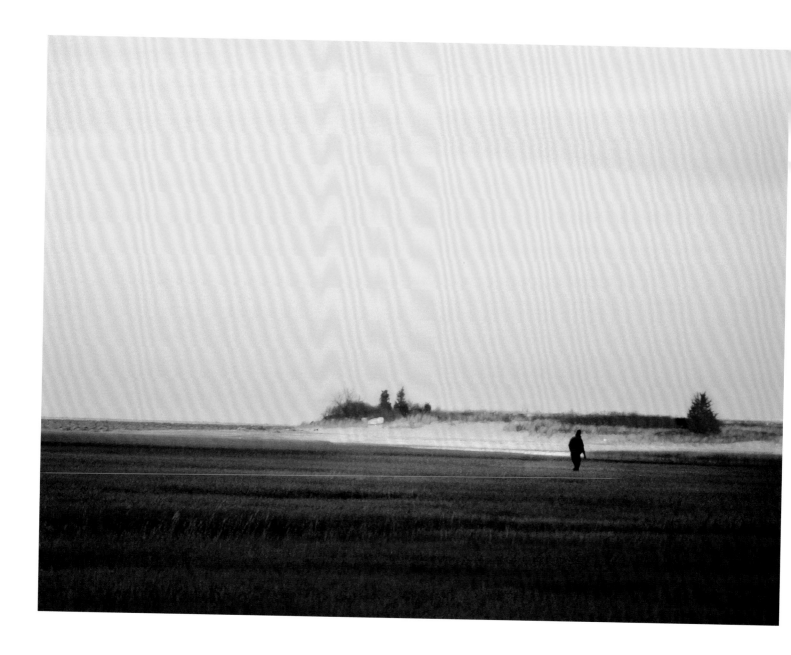

Marsh Walker

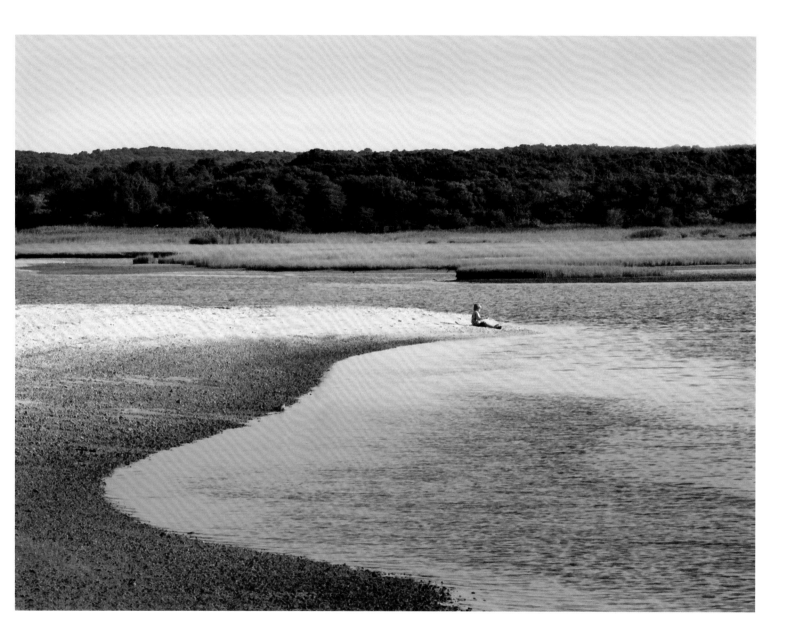

Alone

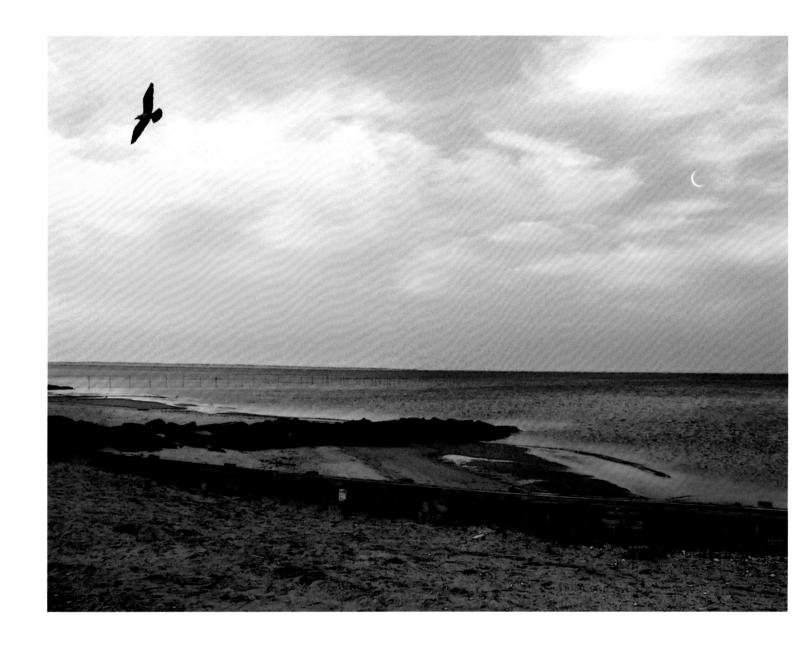

Bayscape, New Moon

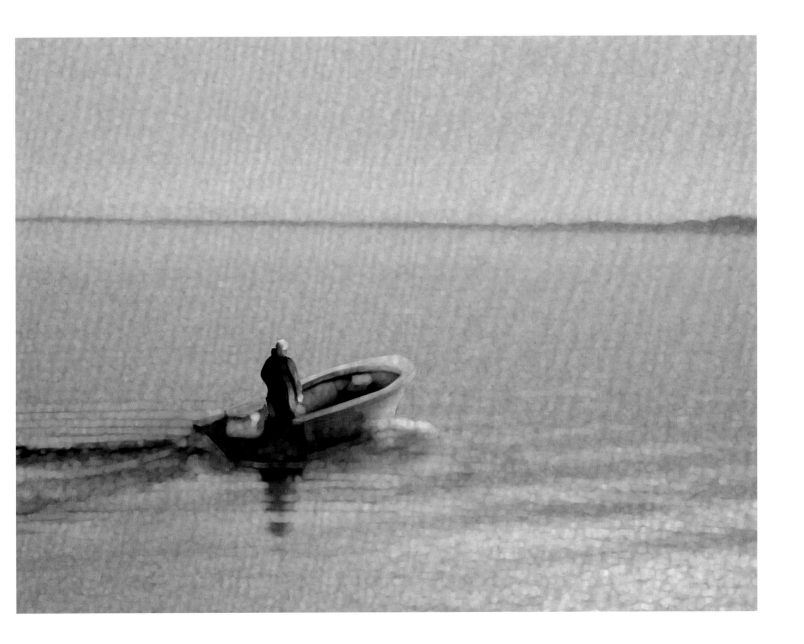

Out Early

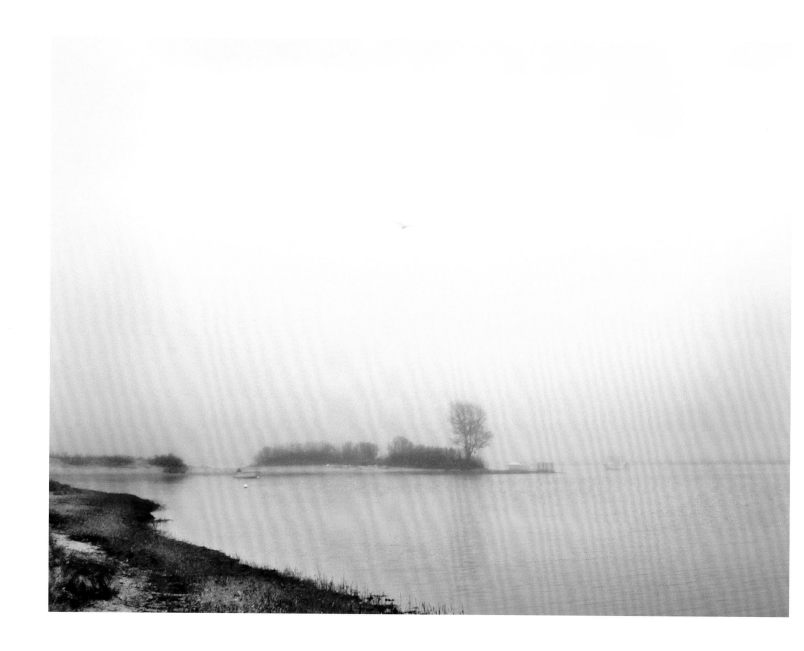

Light and Fog, Louse Point

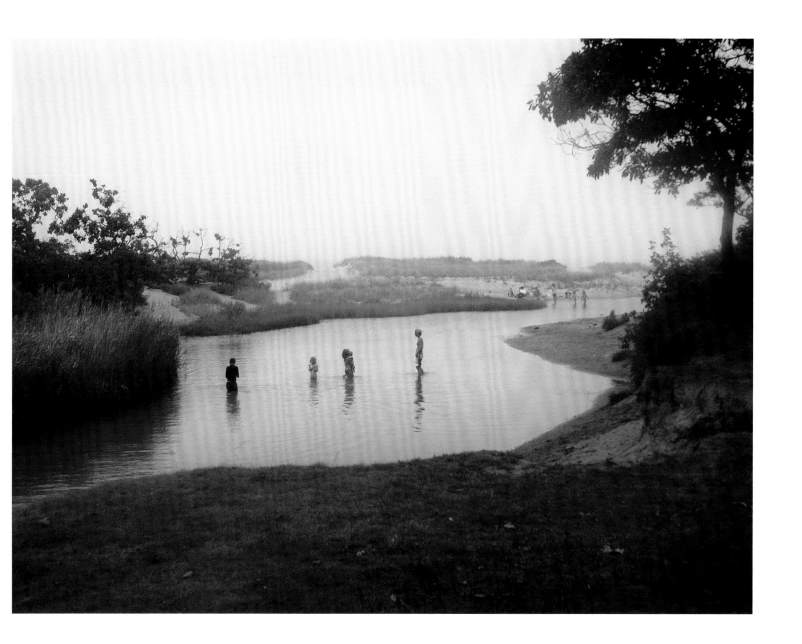

Fresh Pond Bathers

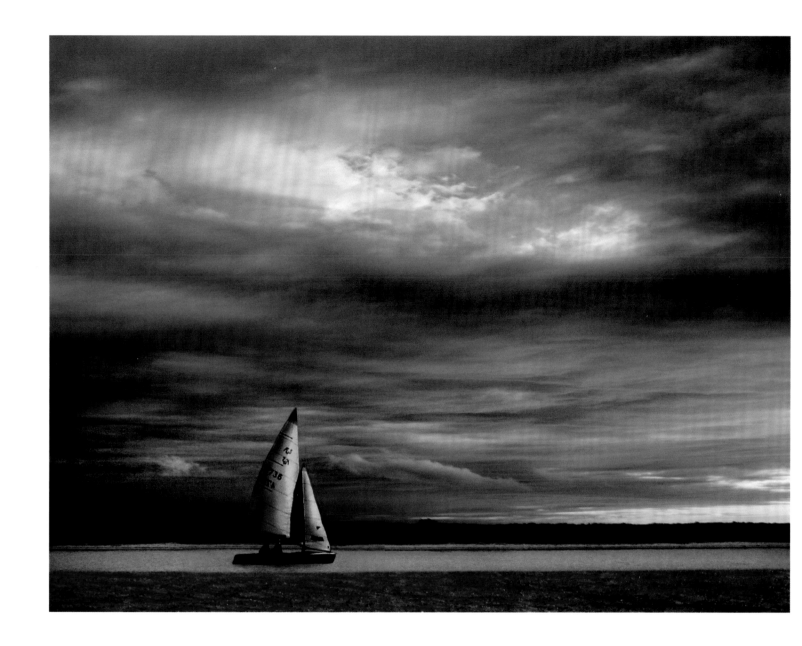

Twilight Sail

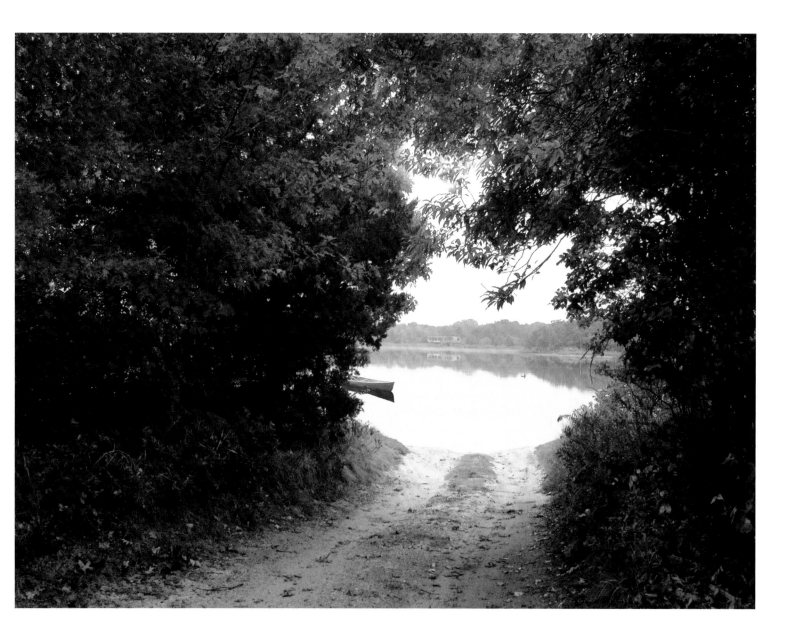

Canoe Launch

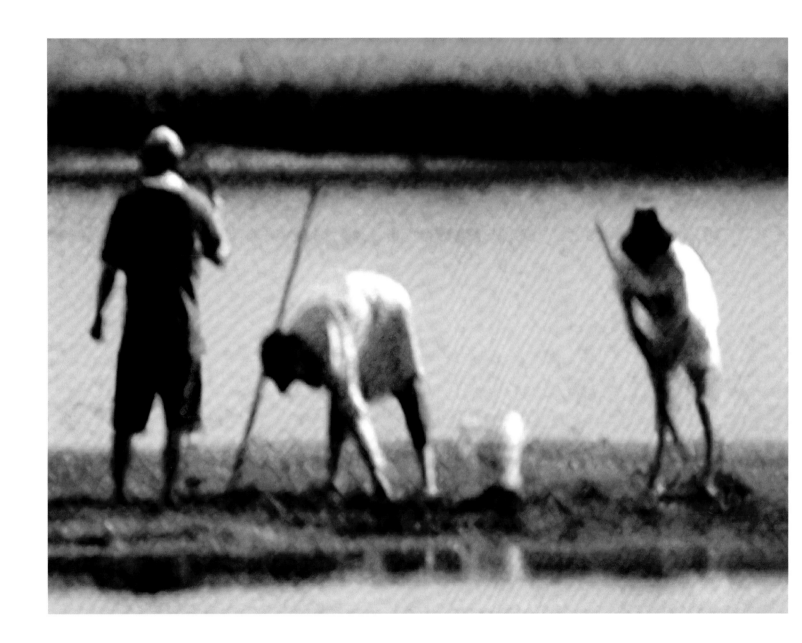

Clamming

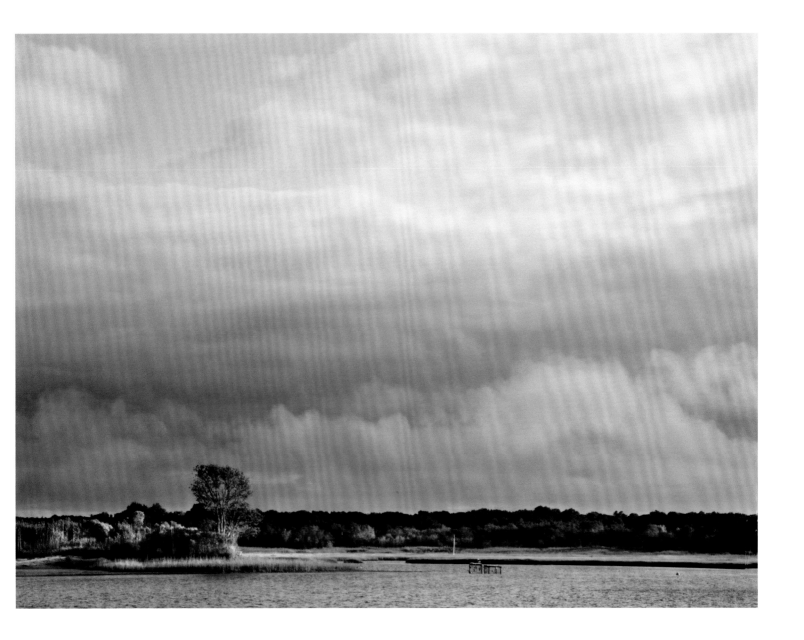

Clearing Sky, Louse Point

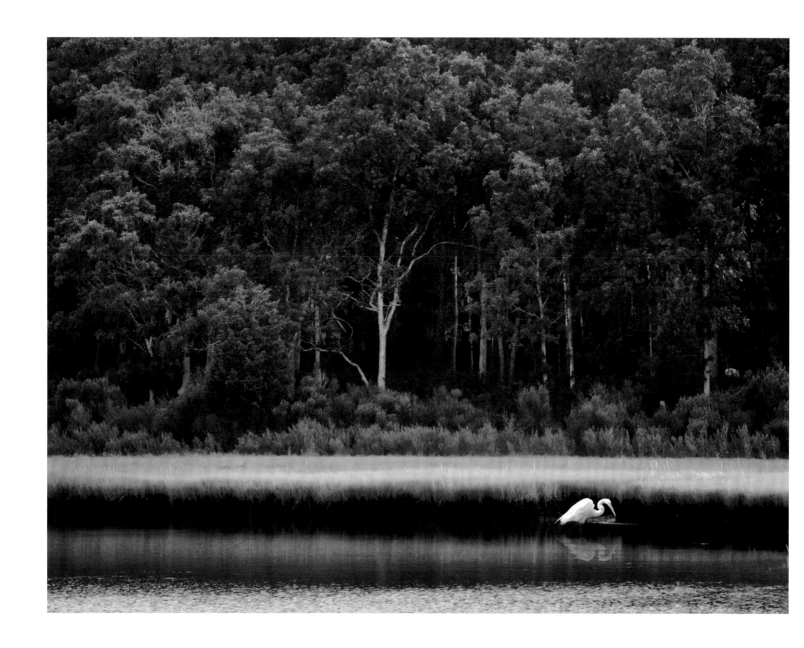

Edge of the Woods

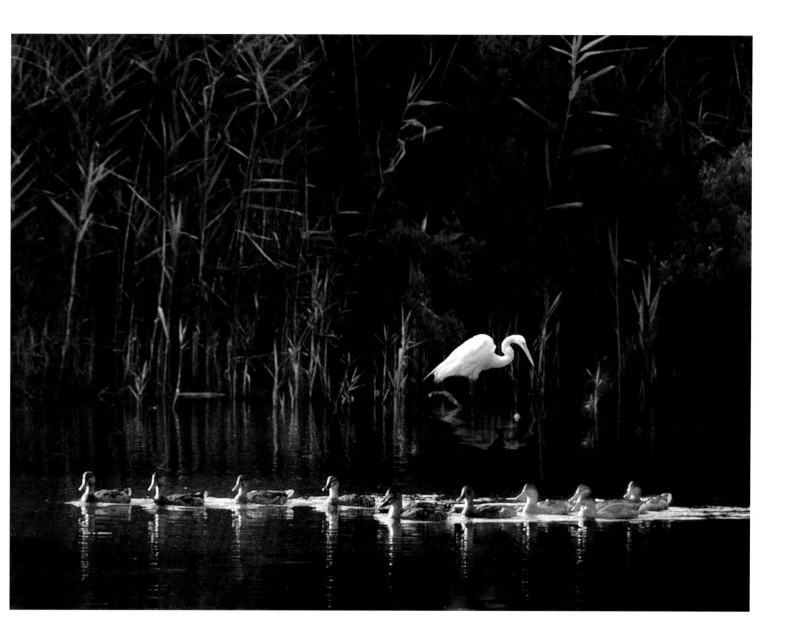

Life Among the Reeds

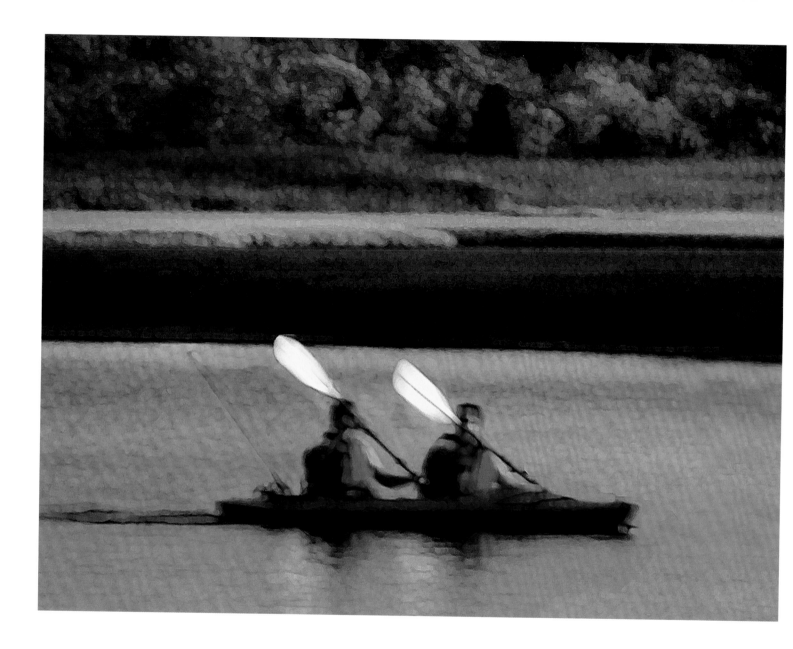

Synchronicity

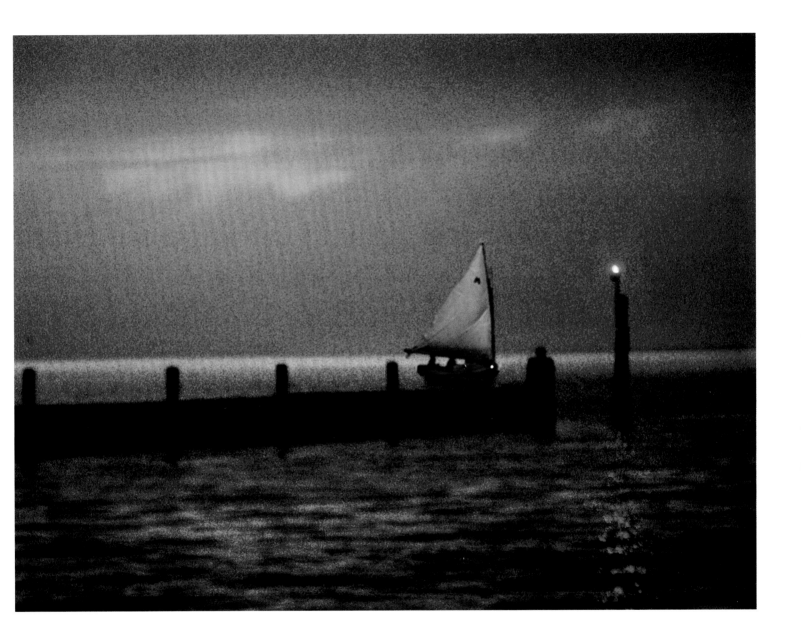

Harbor Entrance

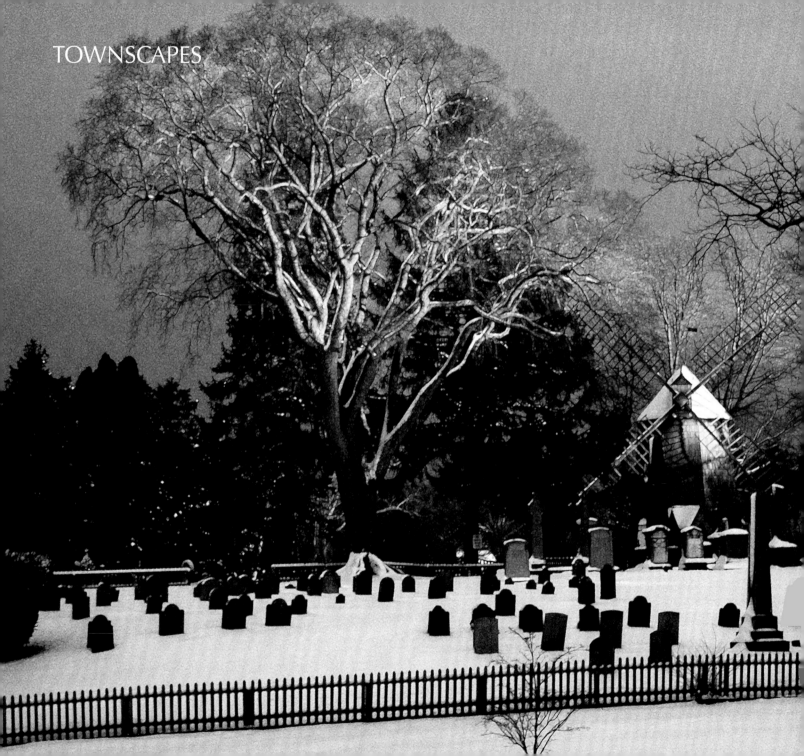

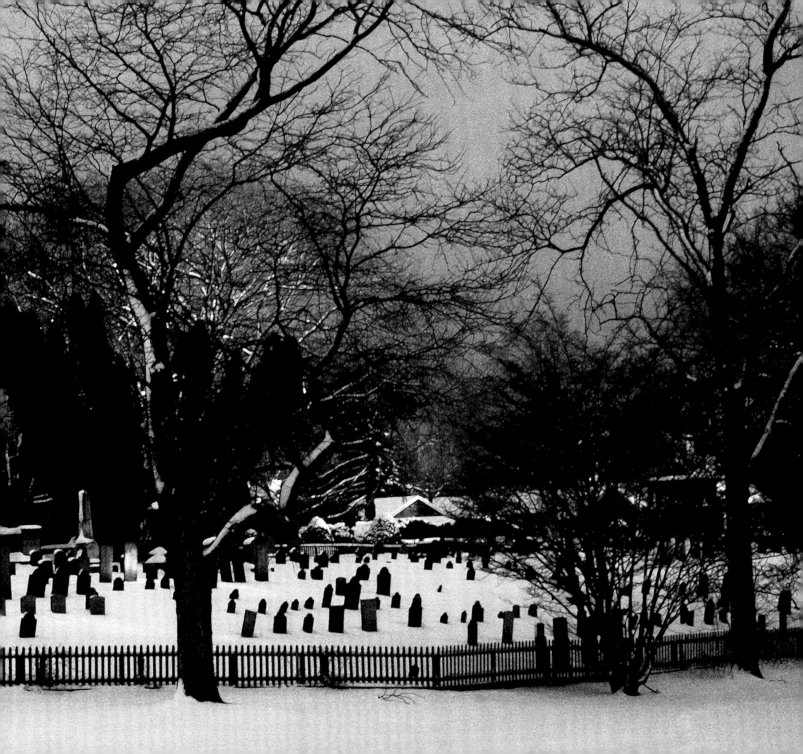

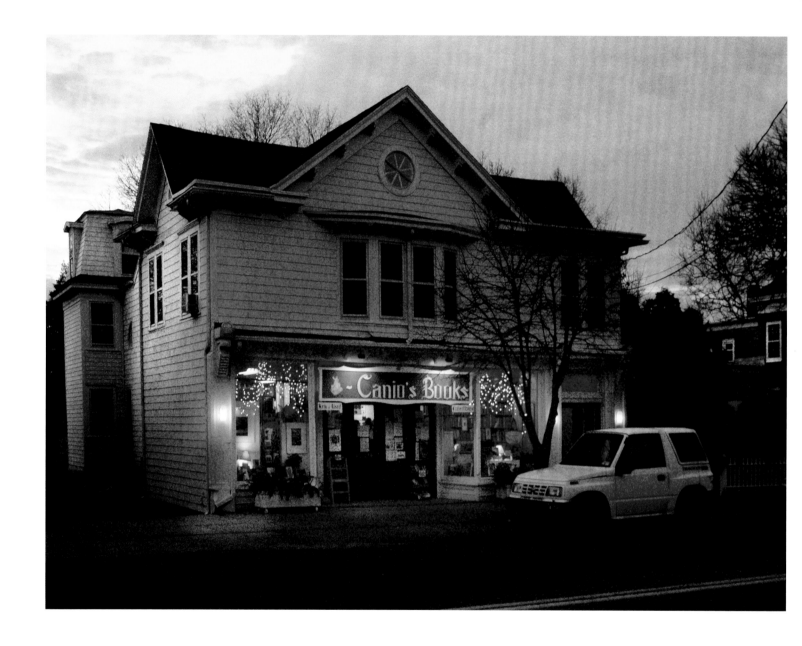

Canios's Bookstore

Author Party

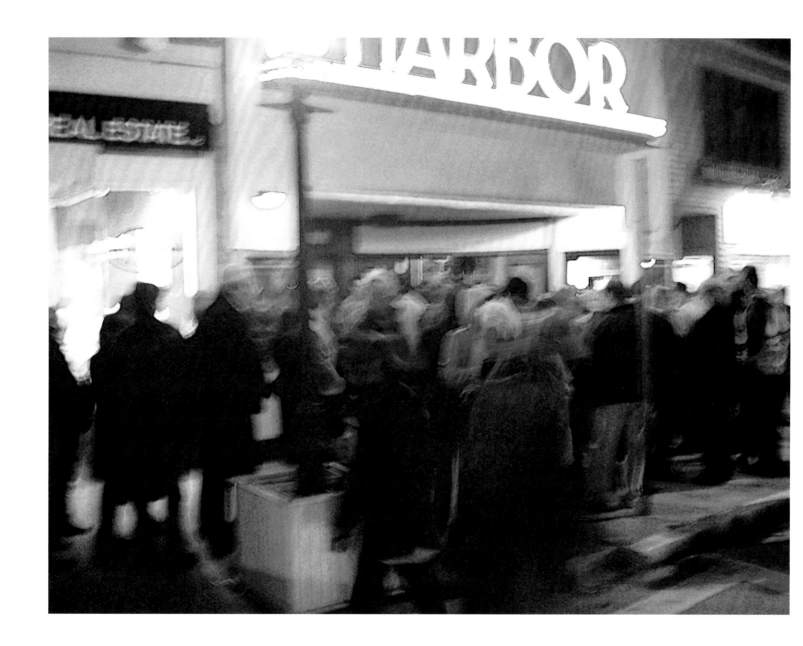

Sag Harbor Movie Theater

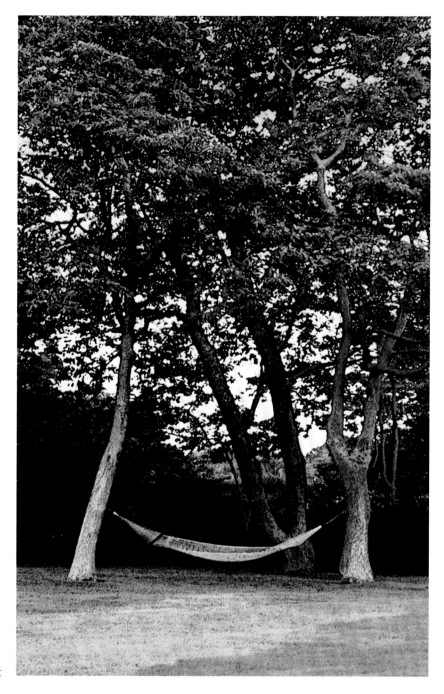

Hammock

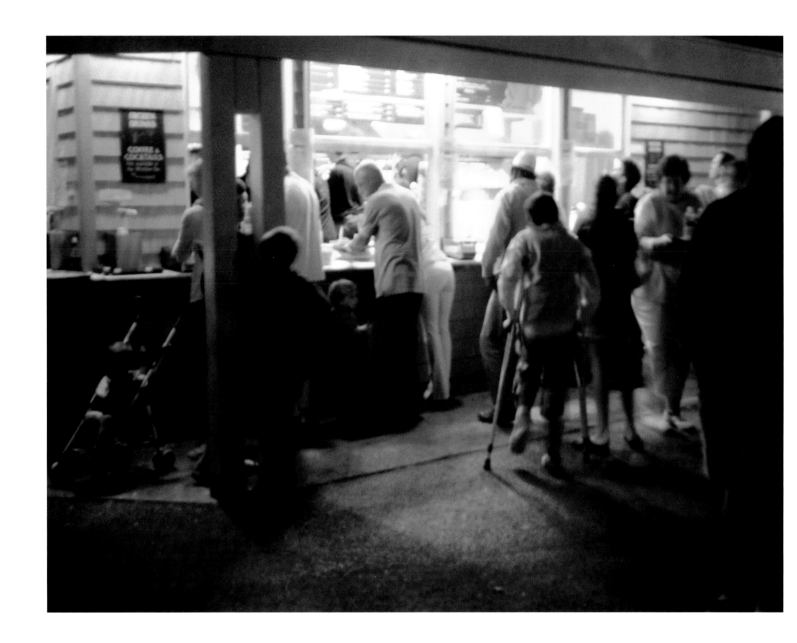

Ice Cream Counter, Montauk

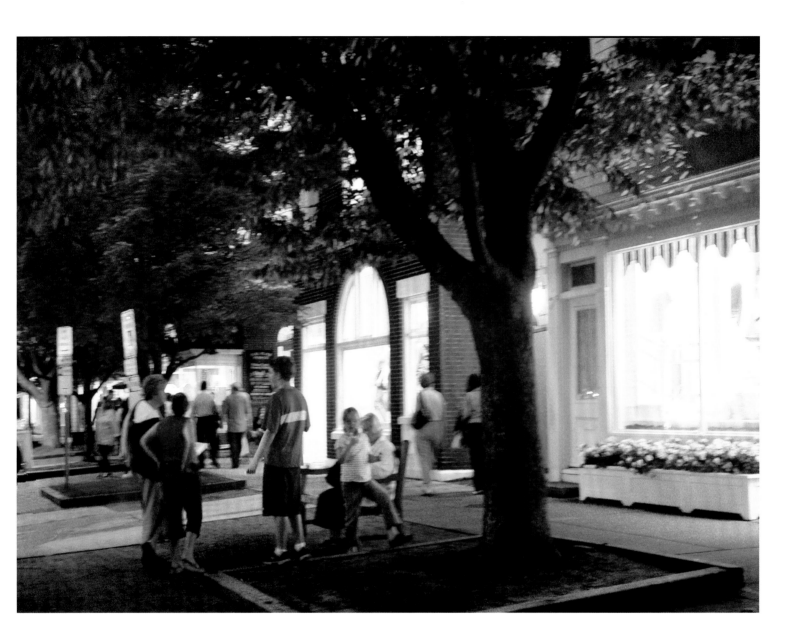

Main Street, Summer Evening

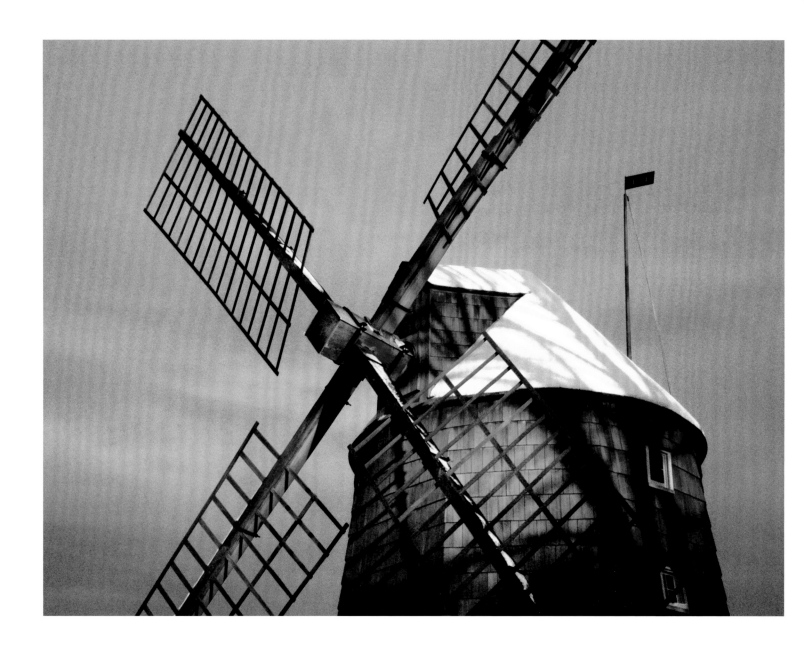

Hook Mill in Winter

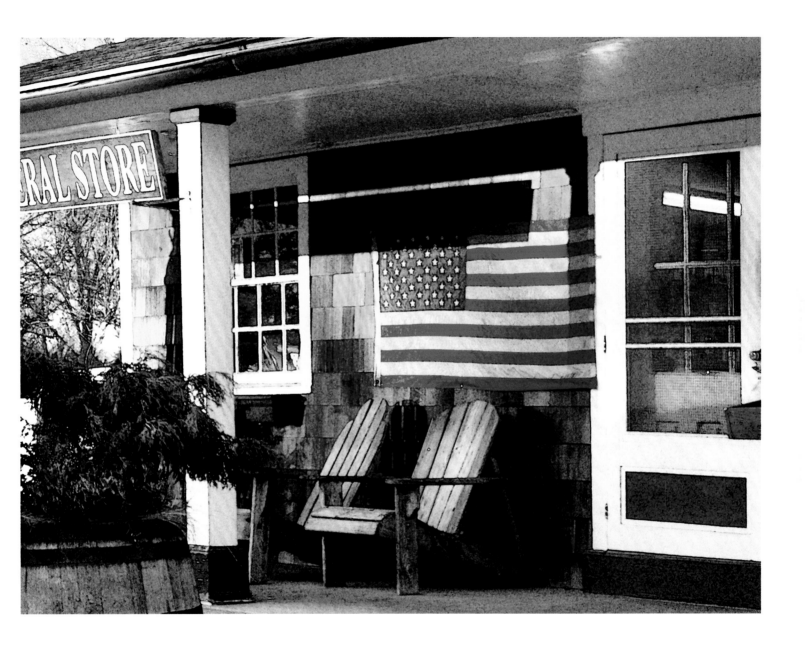

Springs General Store

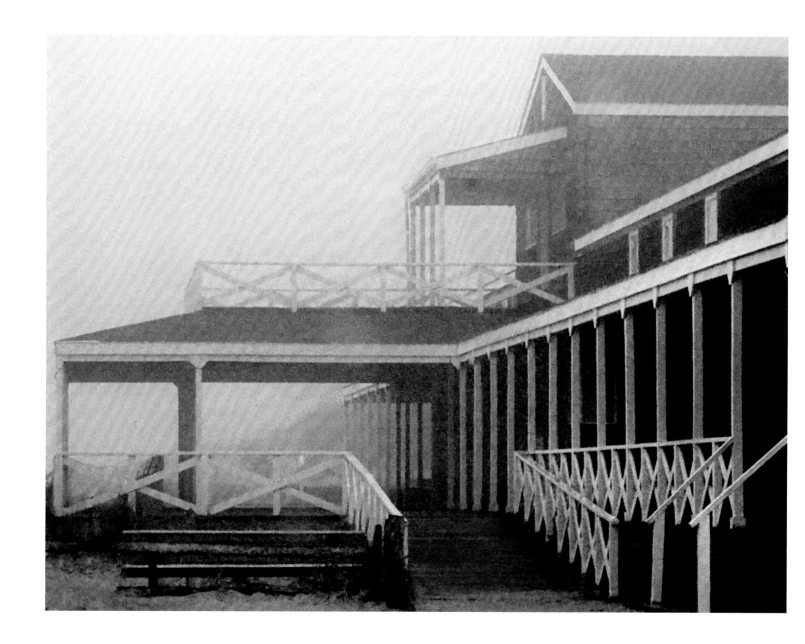

Main Beach Pavillion

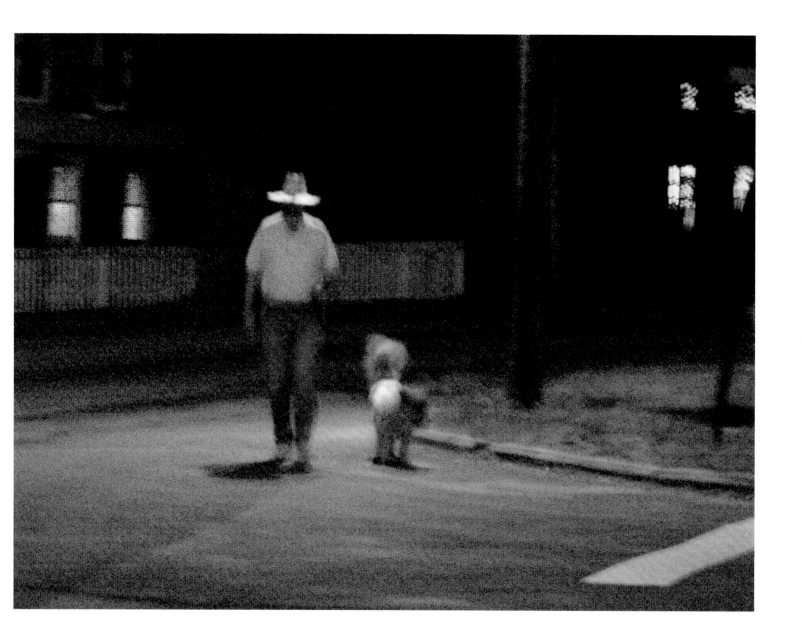

Night Walk

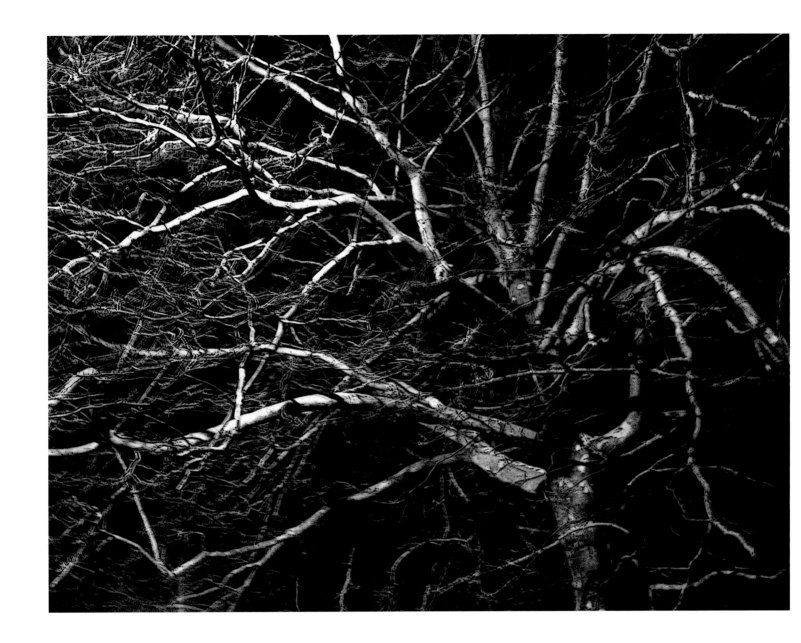

Streetlight

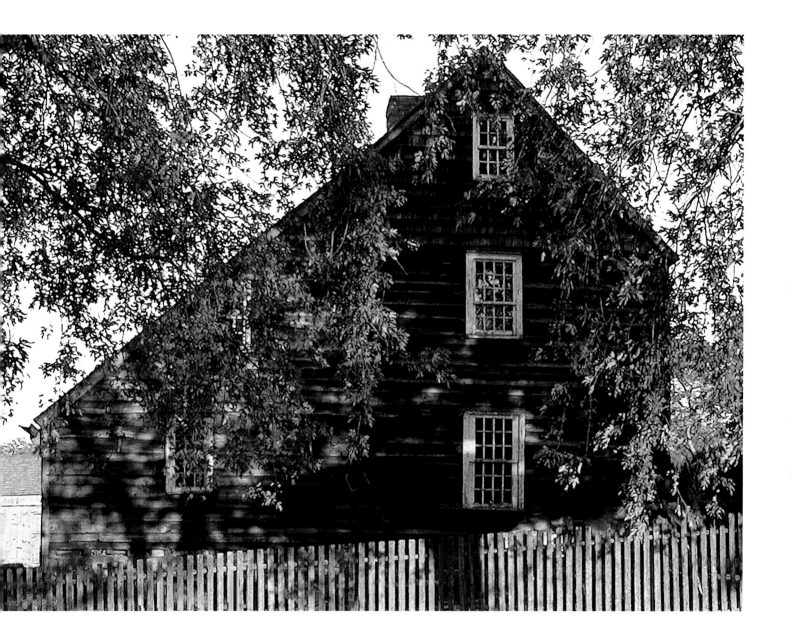

Mulford Farm

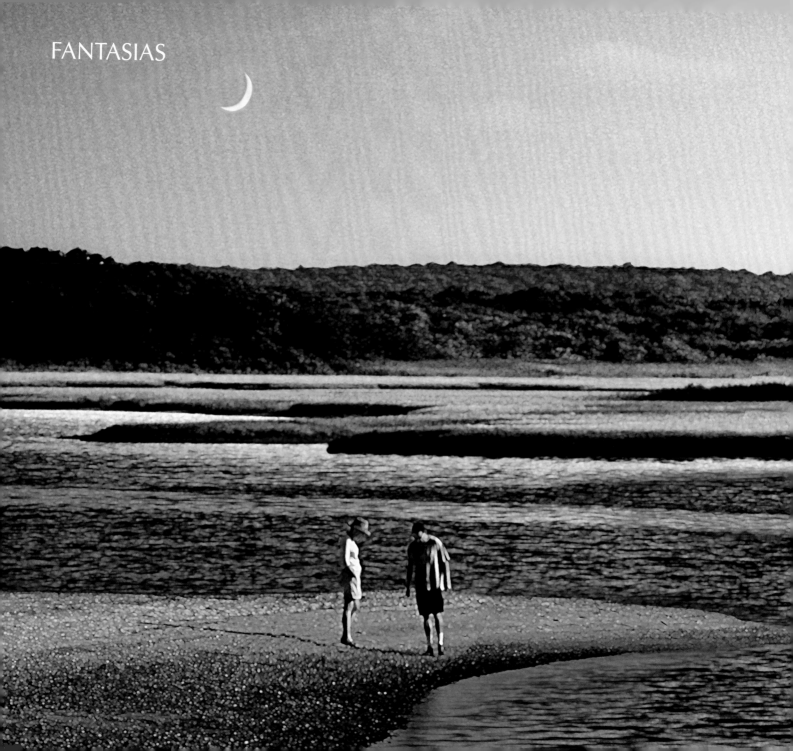

FANTASIAS

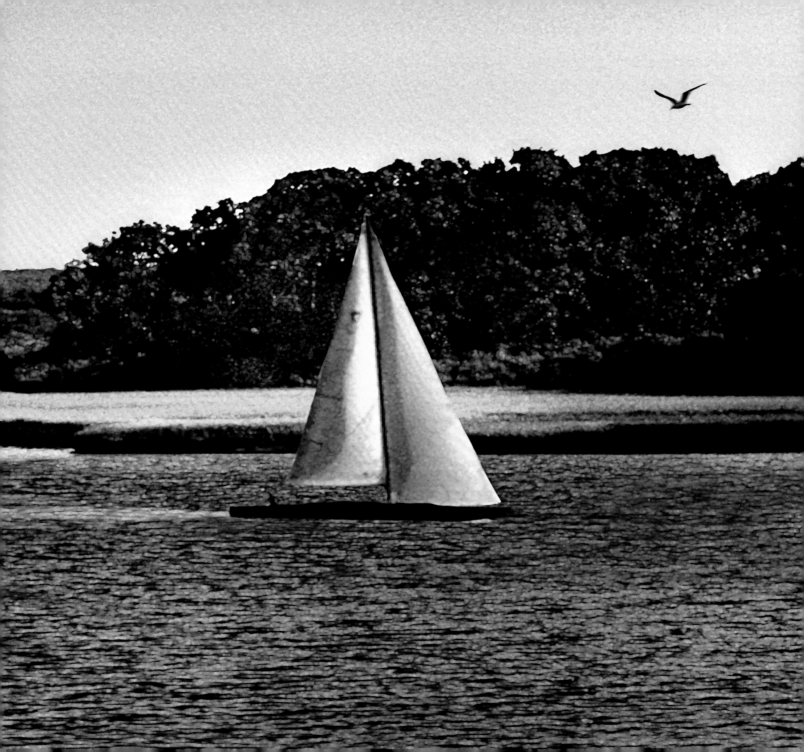

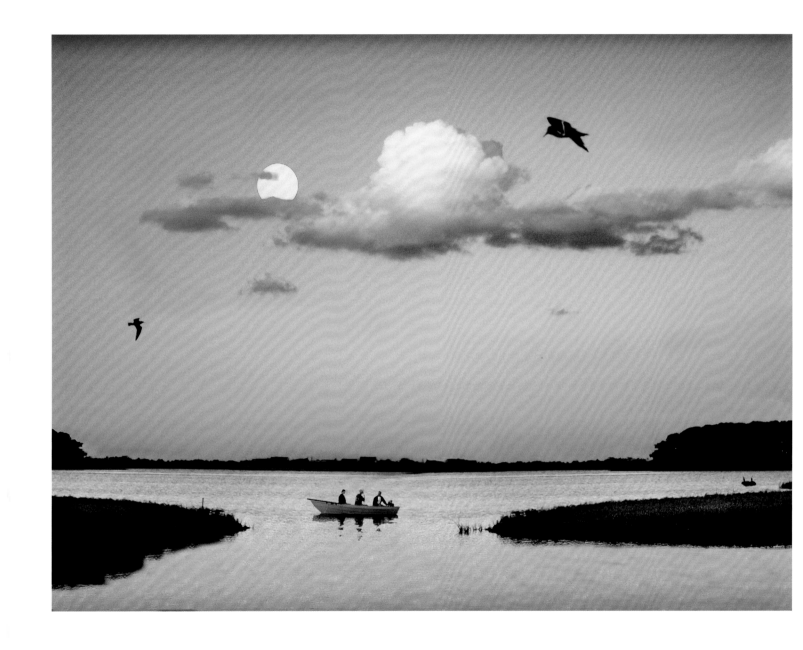

The Crossing

Previous pages: *Summer Idyll*

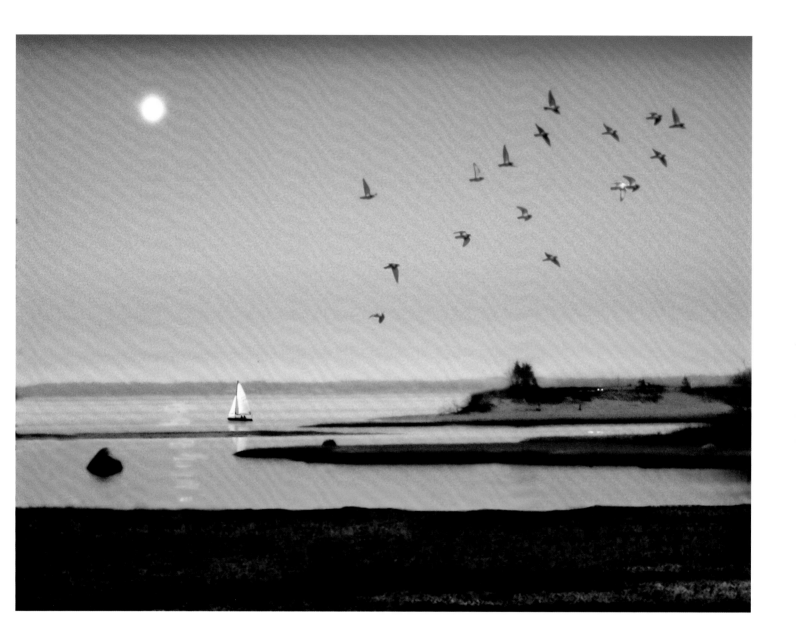

Tick Island Fever Dream

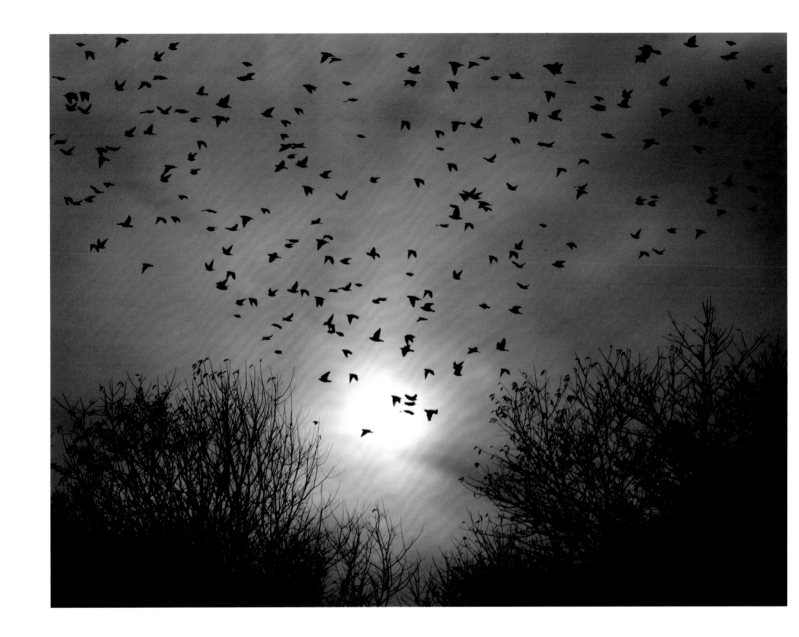

Solar Vortex

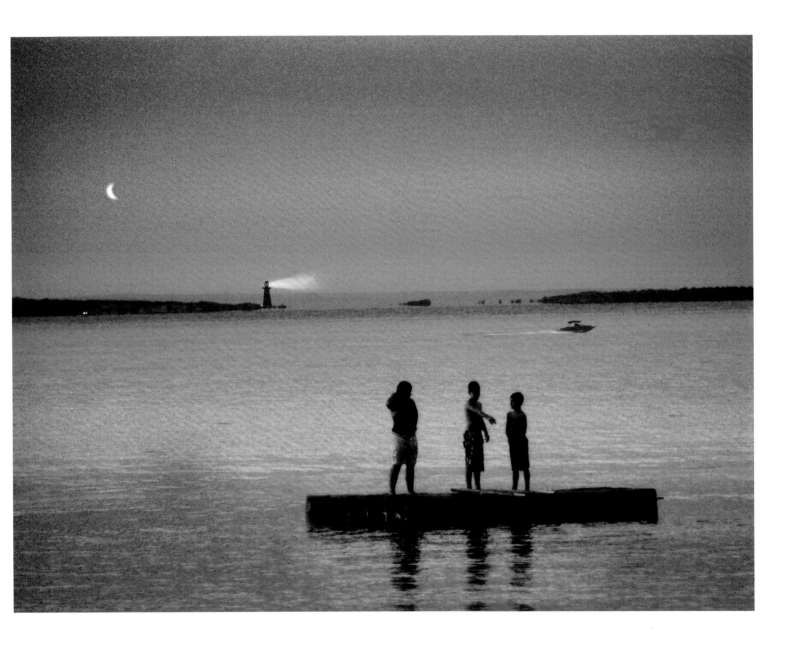

Three on a Raft

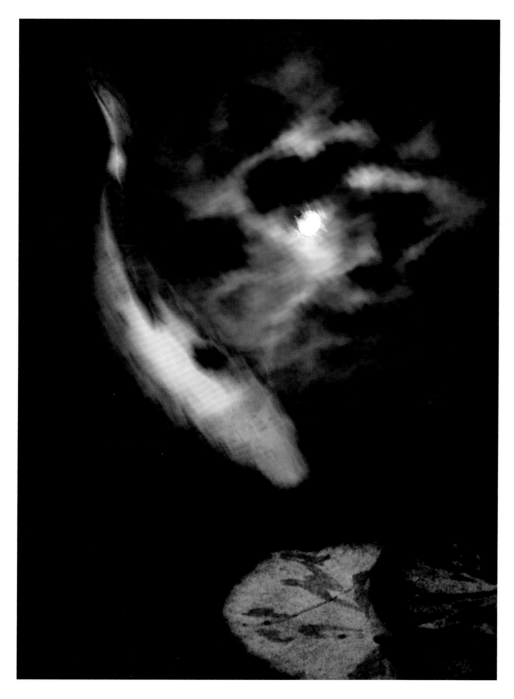

Metaphorical Depth

Pond Fever

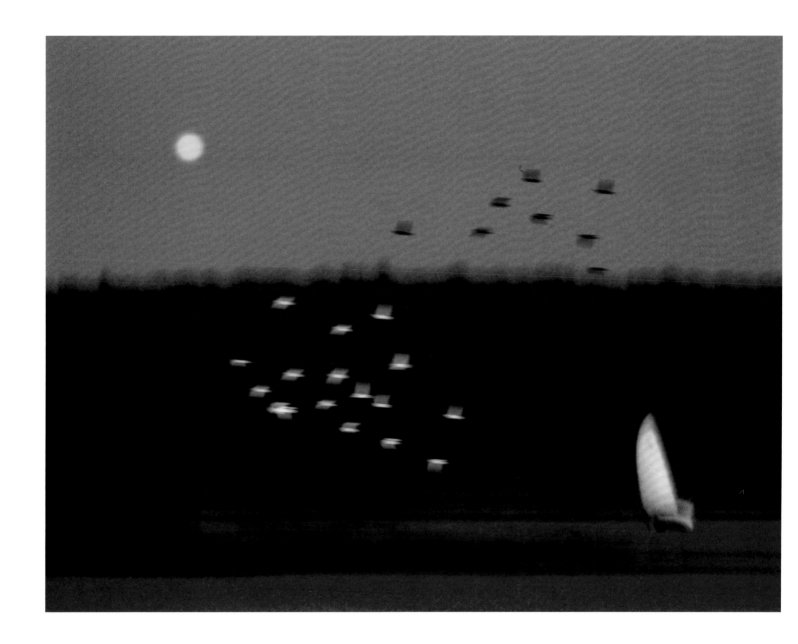

Event Horizon

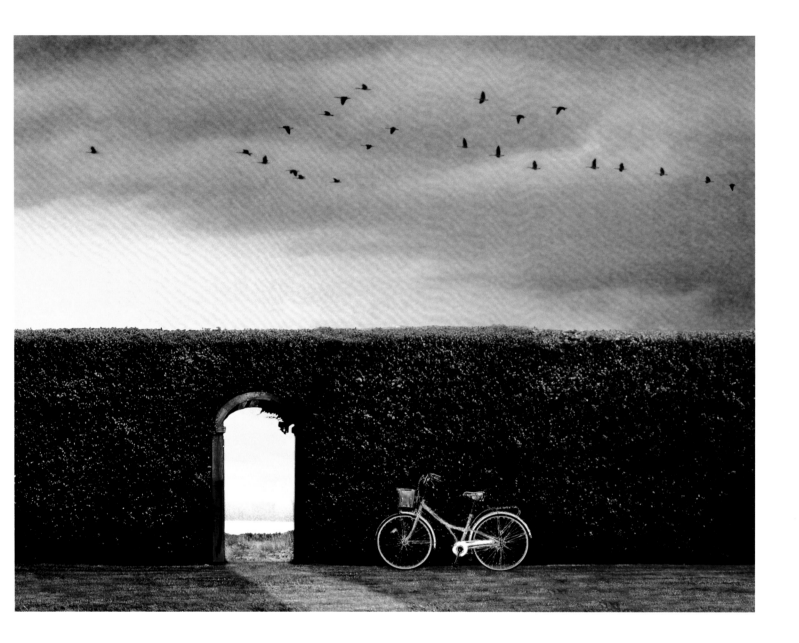

The Gated Hedge

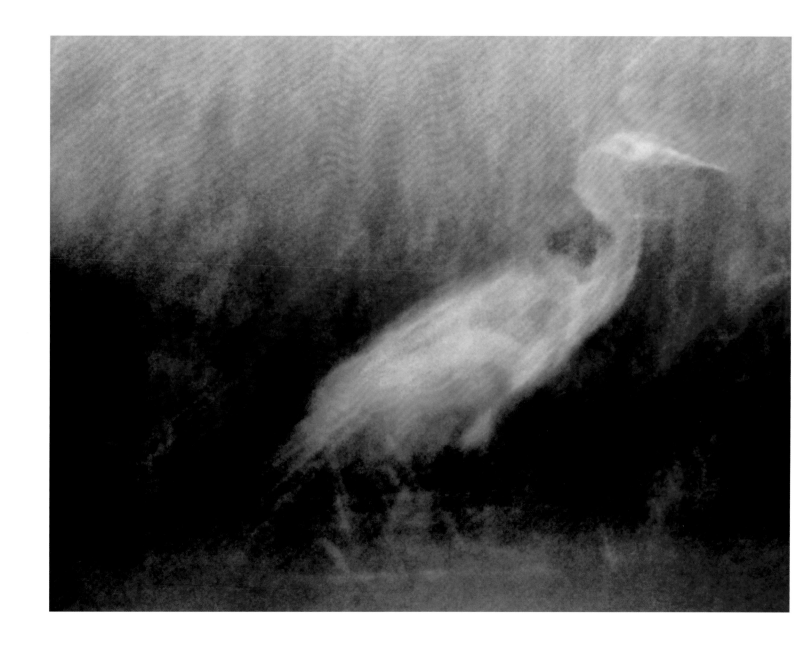

Ghost Heron

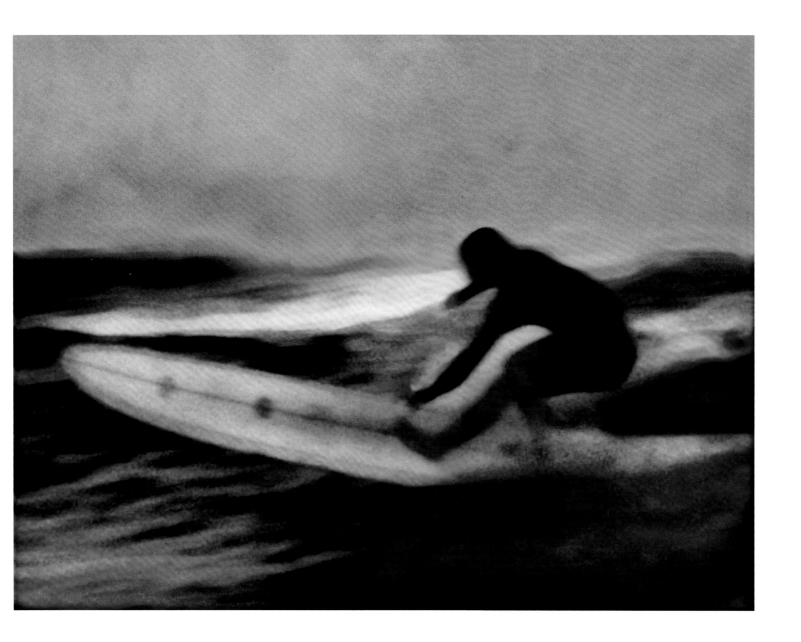

Surf Wraith

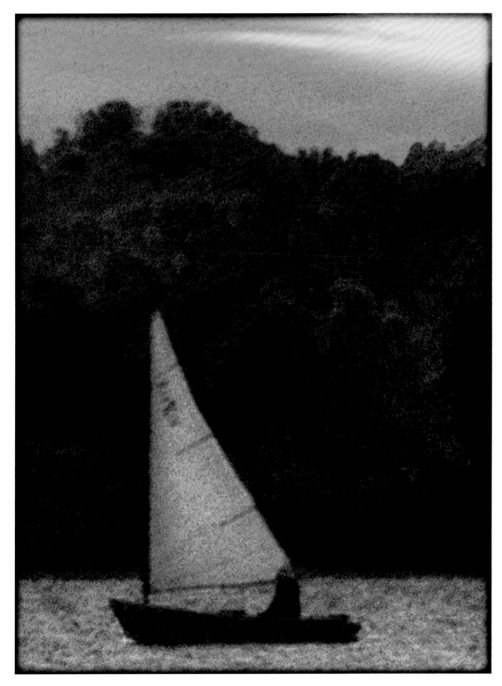

Late Sail

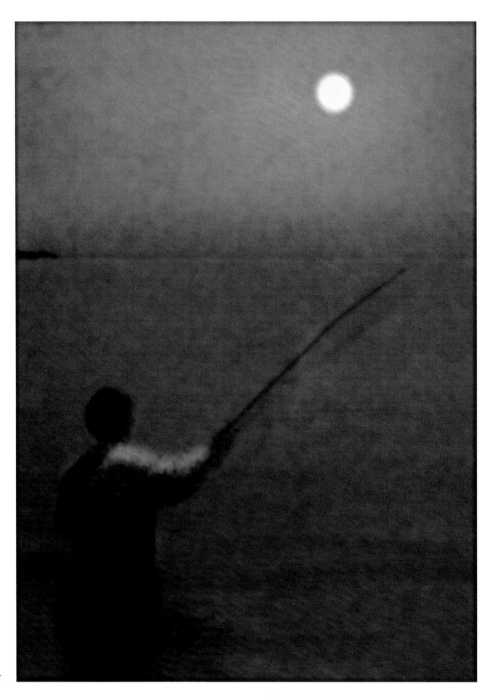

Moonfisher

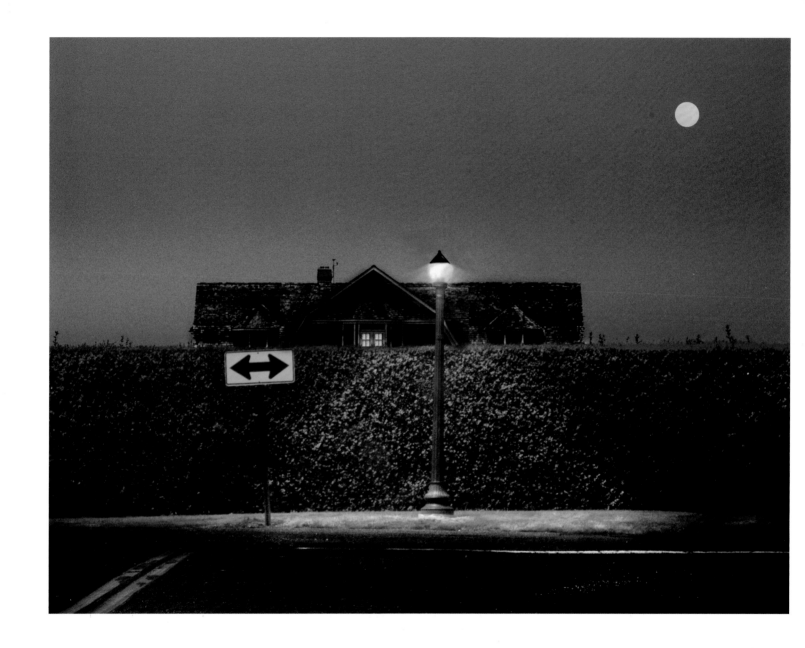

The Privet Paradox